Painting with
Brenda Harris

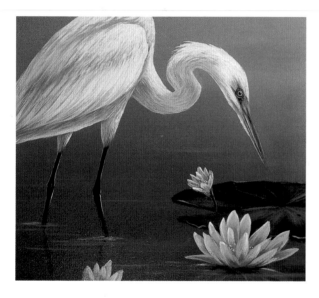

VOLUME 2:
PRECIOUS TIMES

NORTH LIGHT BOOKS
CINCINNATI, OHIO
www.artistsnetwork.com

Painting With Brenda Harris, Volume 2:Precious Times. Copyright © 2005 by Brenda Harris. Printed in Singapore. All rights reserved. No part of this book may be reproduced in any form or by any electronic or mechanical means including information storage and retrieval systems without permission in writing from the publisher, except by a reviewer who may quote brief passages in a review or copying the patterns on pages 97–109 for personal use only. Published by North Light Books, an imprint of F+W Publications, Inc., 4700 East Galbraith Road, Cincinnati, Ohio 45236. (800) 289-0963. First Edition.

Other fine North Light Books are available from your local bookstore, art supply store or direct from the publisher.

09 08 07 06 05 5 4 3 2 1

DISTRIBUTED IN CANADA BY FRASER DIRECT
100 Armstrong Avenue
Georgetown, ON, Canada L7G 5S4
Tel: (905) 877-4411

DISTRIBUTED IN THE U.K. AND EUROPE BY DAVID & CHARLES
Brunel House, Newton Abbot, Devon, TQ12 4PU, England
Tel: (+44) 1626 323200, Fax: (+44) 1626 323319
Email: mail@davidandcharles.co.uk

DISTRIBUTED IN AUSTRALIA BY CAPRICORN LINK
P.O. Box 704, S. Windsor NSW, 2756 Australia
Tel: (02) 4577-3555

Library of Congress Cataloging in Publication Data
Harris, Brenda
Painting with Brenda Harris. Volume 1, cherished moments / Brenda Harris.—
1st ed.
 p. cm.
 Includes index.
 ISBN 1-58180-698-1 (pbk. : alk. paper)
 1. Painting--Technique. I. Title: Cherished moments. II. Title.

ND1500.H34 2005
 751.4--dc22 2004023642
 1-58180-698-1

Edited by Layne Vanover and Christina Xenos
Interior designed by Barb Matulionis
Production edited by Erin Nevius
Production coordinated by Mark Griffin
Photography by Roger Harris

Metric Conversion Chart

To convert	to	multiply by
Inches	Centimeters	2.54
Centimeters	Inches	0.4
Feet	Centimeters	30.5
Centimeters	Feet	0.03
Yards	Meters	0.9
Meters	Yards	1.1
Sq. Inches	Sq. Centimeters	6.45
Sq. Centimeters	Sq. Inches	0.16
Sq. Feet	Sq. Meters	0.09
Sq. Meters	Sq. Feet	10.8
Sq. Yards	Sq. Meters	0.8
Sq. Meters	Sq. Yards	1.2
Pounds	Kilograms	0.45
Kilograms	Pounds	2.2
Ounces	Grams	28.6
Grams	Ounces	0.035

Brenda Harris started painting as a hobby at the age of thirty-one. A few years later, encouraged by her family and friends, she entered her first juried art show. Her style and ability to capture one's imagination proved to be a winning combination; she was awarded high honors in the show. She continued to exhibit in shows, winning numerous awards. However, it was not until she started sharing her techniques with others that her true talent emerged: teaching.

Armed with boundless energy, unlimited patience and a love for painting, she began teaching workshops for a small group of friends in Jacksonville, Florida. From these small but enthusiastic workshops has come an instructor of national television acclaim.

Since 1987, Brenda has taught thousands of students via public television, filming more than 180 educational shows. In addition, she has written more than a dozen instruction books. Her books, her classroom persona and her paintings reflect her true joy of sharing and attention to detail.

Although Brenda's schedule is demanding, her favorite times are those spent sharing and teaching in small paint-along workshops. She believes that nothing replaces the one-on-one personal touch.

For more information about Painting With Brenda Harris *seminars, books, lesson plans, instructional videos and*

painting supplies, contact:
Painting With Brenda Harris
P.O. Box 350155
Jacksonville, FL 32235
Phone: (904) 641-1122
Fax: (904) 645-6884
brenda@brendaharris.com
www.brendaharris.com

About the Author

Acknowledgments

Gratefully, I acknowledge all devoted teachers, both past and present, for their efforts to make our world a better place by unselfishly sharing their knowledge. Knowledge is the key to open all doors. By expanding our knowledge we can change not only our own lives, but the world.

I extend my gratitude to my art teaching pals and TEAM teachers, who have stood by me over the years with encouragement and friendship. You are like an extended family to me. Although we come from a variety of backgrounds, specializing in different styles and mediums, we share the same goal: to make the world a happier place by teaching, and sharing the joy and gratification that comes from being creative. You truly deserve rave reviews!

Accolades to the terrific staff at North Light Books, especially Layne Vanover, Christina Xenos, Pam Wissman and Julia Groh. In their own special way, they have been wonderful to work with. These ladies made all my North Light Books possible. Thanks, ladies, for your professionalism, confidence and support.

To Gary Saltsgiver and the professional staff at WJCT, PBS, Jacksonville, Florida, a big handshake of gratitude. You have been great! Thanks for working with North Light to make the *Painting With Brenda Harris* TV series available for national viewing.

Finally, my love and an extra special thank you to my husband, Roger, for devoting many arduous hours to photographing the projects in this book.

Dedication

I dedicate this book to all my loyal students, and viewers of my television shows. Without your support over the years, I would not have the inspiration to keep on filming and writing. You encourage me to continue.

For all the art and craft shop owners and seminar chairpersons who have been a part of my life and provided me a wonderful place to teach and meet new people.

Thanks to all my family for their understanding, confidence and loving support over the years. I send special hugs and kisses to my incredibly special granddaughters, Breanna and Hollie Ann.

I extend particular appreciation to my nephew, Clay Collier, attorney at law, for continuing to work on my behalf. He is my champion!

I treasure all of you.

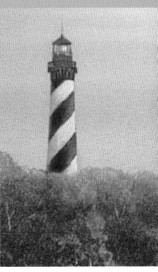

Table of Contents

Introduction ... 6

Brenda's Basic Techniques 7

Acrylic Paint and Mediums..................................... 8

Using a Palette and Mixing Colors 9

Working With Your Brushes 10

PROJECT ONE .. 12
Come On In

PROJECT TWO.. 18
From Whence We Came

PROJECT THREE.. 26
By the Dock of the Bay

PROJECT FOUR.. 32
Along the Water's Edge

PROJECT FIVE... 38
Approaching St. Augustine

PROJECT SIX ... 44
Maine Moorings

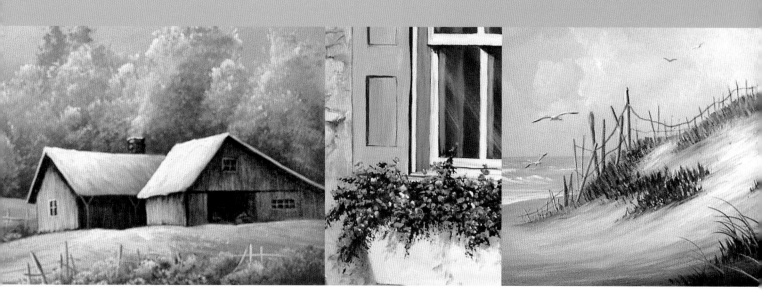

PROJECT SEVEN... *50*
Lobster Joe

PROJECT EIGHT ... *56*
Last Stop

PROJECT NINE.. *62*
Garden Window

PROJECT TEN ... *68*
Sky High

PROJECT ELEVEN ... *76*
The Bunkhouse

PROJECT TWELVE .. *84*
Tickled Pink

PROJECT THIRTEEN.. *90*
End of Summer

Conclusion.. *96*

Patterns... *97*

Index.. *110*

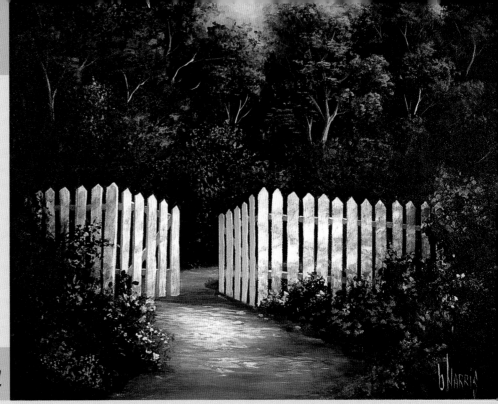

Come On In
14" x 18" (36cm x 46cm)

Introduction

I have heard it said many times that if you don't know where you are going, you will never get there. No matter where we want to go or what we plan to do in life, we need a road map to help us get there. It's the same with painting. I hope I can help you on the road to becoming an artist. I also hope the PBS series sponsored by North Light Books along with this book will be a road map for your artistic learning journey.

As part of your learning journey, visit fine art galleries, study the variety in the styles of artwork displayed and look at the painting evolution from the Old Masters to the modern artists. Fine art ranges from photorealistic to abstract, and everything in between. Fine art cannot be measured; it is an expression of oneself. Many artists working today have developed the skills and use the same techniques as the masters, yet others prefer a completely different approach. All are applauded.

There is no right or wrong way to paint, unless you are doing so with a frown on your face, so you can put your mind at ease, relax and experiment. Sure, you are going to have trouble spots and bumps in your road; that is a part of learning. Laugh it off and try again. The more you practice, the more skilled you become. Mastering a variety of techniques will give you a solid foundation and the skills necessary to develop your own style. As you work on the projects in this book, think of how you can use the techniques to create your own compositions, the paintings that you will create when you develop your skills and confidence.

Keeping a good attitude is important. Be confident that you will reach your goal. I have confidence in you, so off you go on your fun, artistic, learning journey!

Brenda's Basic Techniques

Throughout this book you will work with patterns (pages 97–109) that you will enlarge for each painting. In some projects you will also use design protectors and mats. This page explains these three techniques.

Transferring a Pattern

Enlarge the pattern according to the percentage indicated. Lay the canvas on a flat, sturdy surface and tape the pattern firmly in place. Insert a piece of white or black transfer paper, powdery side down, between the pattern and the canvas. Trace the lines with a stylus or a ballpoint pen that no longer writes. While the pattern is still taped in place, lift a corner to check for missed lines.

Remove any visible transfer lines with a kneaded eraser or a clean, moist sponge after the painting has dried.

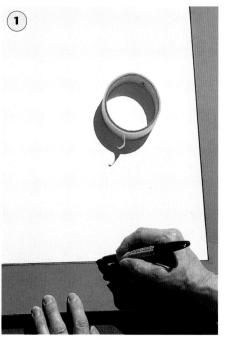

Using an Adhesive Design Protector

When you paint the background first, you'll often need to protect an area of your painting. Trace the outline of the area you need to protect onto a piece of adhesive paper or label using the same technique as transferring a pattern. Cut out the image, remove the backing, align the design protector over the traced image and press it onto the dry canvas.

Paint carefully around the protector. Whenever possible, start with the brush on the protector and stroke away from it, because stroking toward the design protector may force paint under it. When you are ready to paint the image under the protector, carefully peel the protector off the canvas.

French Matting

(1) Place the canvas on a flat surface, then place the mat template (precut photograph matting that can be purchased from any craft or framing store) over it. Hold the mat template securely and trace the inside edges with a waterproof permanent marker or technical pen. (2) Remove the template and let the ink dry. Cover the border with masking or shipping tape, overlapping the tape about ½ inch (12mm) inside the ink lines on all four sides. (3) After the painting is finished, remove the tape to reveal an unpainted border around your painting.

If you would like to create the appearance of double matting, you can use two templates, one with a slightly larger opening. To prevent color seepage under the tape while painting, seal the tape by applying Clearblend over the inside edges of the tape, fading toward the center of the canvas.

Acrylic Paint and Mediums

Acrylic Paint

You can paint with with acrylic tube colors or bottled acrylics. All brands of acrylic paint dry at about the same rate and can be mixed and cleaned up with water. Use cool, clean water when mixing, painting with or cleaning up acrylic paints. Never use oils, thinners or turpentine with acrylics.

Select a brand that is easily accessible and affordable for you. You can set up your palette with colors from several different brands and combine bottled and tube acrylics in the same palette. Most of the colors will not be applied purely from the tube; instead, they will be tinted with white or toned by mixing with other colors.

When applied, acrylics dry at an uneven rate. Often the outer edges of an application begin to dry first; this can cause a spotty appearance. Usually, the color will even out and darken when it is completely dry. Speed the drying with a hair dryer held a few inches away from the canvas. Use a low temperature and keep moving the dryer around above the canvas.

Mediums

For the projects in this book, I have used three types of acrylic mediums, which let you create beautiful color

Miscellaneous Supplies	
14" × 18" (36cm × 46cm), 16" × 20" (41cm × 51cm), 18" × 24" (46cm × 61cm) stretched canvases	Hair dryer
	Liquid soap
	Masking fluid
10" × 14" (25cm × 36cm) sheet of 140-lb. (300gsm) cold-pressed watercolor paper	Old brush for applying masking fluid
	Paper towels
16" x 20" (41cm × 51cm), 18" × 24" (46cm × 61cm) photograph mats	Sand for texturizing paint
	Shipping and masking tape
Acrylic modeling paste	Small, plastic containers for mixing glazes
Adhesive paper	Spray bottle
Aerosol acrylic painting varnish	Sta-Wet palette
Black and white transfer paper	Stylus
Bubble watercolor palette	Ultrafine-point waterproof permanent marker
Cotton swabs	or technical pen (black or dark brown)

blends. There are a lot of different acrylic mediums out there besides these three. Ask your paint supplier for recommendations, or contact me to purchase these directly.

Whiteblend® is excellent for painting wet-into-wet and creating soft, subtle colors. Acrylic paint dries faster and blends better when mixed with it. It can also be used as white acrylic paint, or you can mix it with tube acrylic colors to tint them. Unless otherwise noted, all colors or mixtures should have water or a medium added to them and be mixed to the same consistency as Whiteblend.

Clearblend® adds transparency to colors and dries flexible and water-resistant. It appears white in use but dries clear; it also is permanent when dry. Use it to create soft edges, transparent glazes and gradual blends and washes. It dries at the same rate as Whiteblend and can also be used in a wet-into-wet wash where you do not want to tint or lighten the colors.

Slowblend® is a clear, slow-drying medium. It dries flexible but less water resistant than Whiteblend or Clearblend. It is used primarily to slow the drying time in the final layers and details. Add no more than one part Slowblend to two parts paint; too much Slowblend can compromise the paint binder, which causes paint to lift easily from the canvas. Heavy use of Slowblend is not recommended when subsequent layers of paint are to be added.

Acrylic Colors

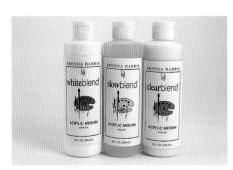

Mediums

Using a Palette and Mixing Colors

I use the Masterson Super Pro Sta-Wet palette system. It consists of a sponge sheet, special stay-wet palette paper and a durable storage container with a lid. Once you moisten the sponge sheet and lay the palette paper over it, you'll be ready to add colors.

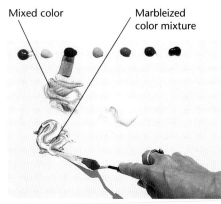

Mixed color Marbleized color mixture

Adding Paints to Your Palette

Place paints on the palette paper to mix your colors. The paint will stay workable as long as the sponge pad and paper remain wet. As the pad dries out around the edges, the paper will curl. When this happens, lift up a corner of the paper, add water to the dry areas of the sponge pad and press the paper back in place.

To store the mixed paint on your palette, carefully lift the paper off the sponge and lay it to one side. Remove the sponge and squeeze out the water. Replace the sponge, then place the paper with the paint back on the sponge. Place the lid on the tray. Your paints will remain the same for several days. If you plan to save the paint longer and want to avoid a musty odor when you open the box, place the tray in the refrigerator.

Mixing Colors Using Your Palette

I have listed color mixtures in every project in this book. You should mix these before you begin to paint. Mixing colors is an art, not a science! Squeeze out a marble-size dollop of each tube pigment along the edge of your palette paper. Use a clean tapered painting knife to pull out a small amount (about the size of a pea) of your main color. Add other colors in lesser amounts and mix to the tint or shade you want. I prefer to leave the mixture slightly marbleized. This gives a mottled, slightly streaky appearance, which adds interest to paintings. It's up to you to decide exact hues; there are no precise formulas. Often it's best to mix colors directly on the brush or sponge. This is useful when only a small amount is needed or when a gradual change of value or color is desired, such as when you add highlights.

Working With Your Brushes

For brushstrokes and techniques there are many terms that often mean different things to different artists. Following are the terms used in this book and definitions of corresponding techniques.

Loading a Brush

Have a large container of clean water handy to moisten your brushes before using them. Squeeze the bristles to remove excess water from large brushes; tap smaller brushes on a clean towel. To get a smooth application, load the brush from side to side. Moisten your brushes frequently while painting to insure smooth and even coverage.

Loading a Painting Knife

Use the tapered painting knife to spread the paint in a thin layer across the palette. Hold the edge of the knife in the paint and pull diagonally to load a ribbon of paint on the edge.

Double Loading

Apply two colors to the brush at one time. Load the brush with the darkest color of the subject, then pull one side of the brush through the highlight color to create a dark and a light side. Position the brush so the stroke is half dark and half light as you move it along the canvas. This technique saves time when used for creating delicate details such as birds or tree limbs.

Side Loading

Load your brush with medium or water, then blot the excess on a paper towel. Dip one corner of the brush into your paint. Gently stroke the brush back and forth to create a gradation between the paint and water or medium. This should produce a

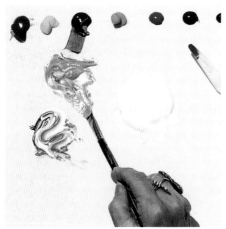

Loading a Brush

Loading a Painting Knife

Side-Loading

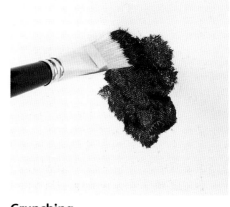

Crunching

Stippling

graded color from bold at one end to neutral at the other. You can also side load your brush using white and a color or using two colors.

Crunching

Hold the brush perpendicular to the canvas and push straight toward the canvas; then, pushing up, bend the bristles slightly, fanning or flaring the bristles out.

Stippling

Flare the brush before and during loading. Hold the brush perpendicular to the canvas and pounce in the paint, causing the brush to flare open. Tap it against the canvas so it applies random, tiny specks of paints. Then apply less pressure and tap the canvas to distribute speckles of paint.

Tapping and Patting

Angle the brush toward the canvas. Using less pressure than for crunching or stippling, lightly tap a small part of the brush tip on the canvas.

Tapping and Patting

Correcting Mistakes

Don't be afraid of making mistakes; we all do. Anything you put on your canvas can be corrected. Remove wet mistakes using a clean, damp sponge, paper towel or brush. If an error is stubborn to remove, gently agitate it with a toothbrush moistened with Slowblend, then wipe it away. If your mistake has dried, paint over it. Could you cover it with foliage or a cloud? Train yourself to think creatively!

Correcting Mistakes

Wet-Into-Wet

Paint a base color, then apply one or more colors directly on the wet base color. Blend the colors together quickly before either dries.

Wet-Next-to-Wet

Apply two acrylic colors next to each other, slightly overlap them. Blend them together where they overlap. This creates a gradual transition between the colors.

Wet-on-Dry

Apply and blend wet acrylic paint over dry acrylic paint. If the color or blend does not suit you, you can remove the wet color with a moist towel or sponge and try again without losing anything.

Wet-on-Sticky, Wet-Next-to-Sticky

Apply and blend wet paint in and around sticky (partially dry) paint. This technique is frustrating and difficult to control. Slick areas of buildup occur, and other spots lift off the canvas. When this happens, it is best to allow the paint to dry thoroughly, then touch it up by painting wet-on-dry.

Brushes

You'll need these brushes to complete the projects in this book.

2-inch (51mm) bristle flat
Nos. 4, 6, 8 and 12 bristle flats
¼-inch (6mm) sable/synthetic flat
No. 12 bristle round
No. 2 sable/synthetic round
No. 2 liner
1½-inch (38mm) hake or ¾-inch
 (19mm) mop (Use either of these
 brushes for blending.)
½-inch (12mm) comb
 (also called a rake)
⅜-inch (10mm) sable/synthetic angle
No. 2 bristle fan
Tapered painting knife
Natural sea sponge

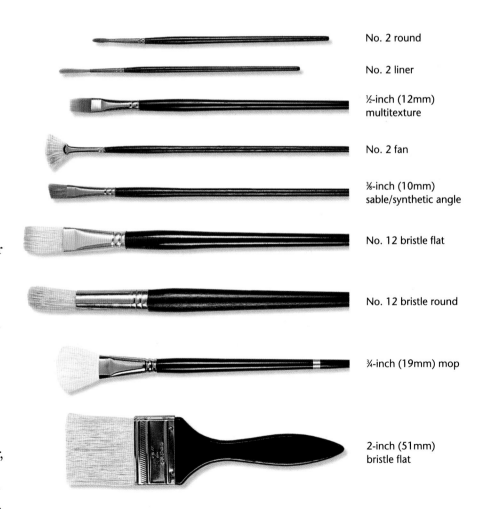

No. 2 round

No. 2 liner

½-inch (12mm) multitexture

No. 2 fan

⅜-inch (10mm) sable/synthetic angle

No. 12 bristle flat

No. 12 bristle round

¾-inch (19mm) mop

2-inch (51mm) bristle flat

Come On In

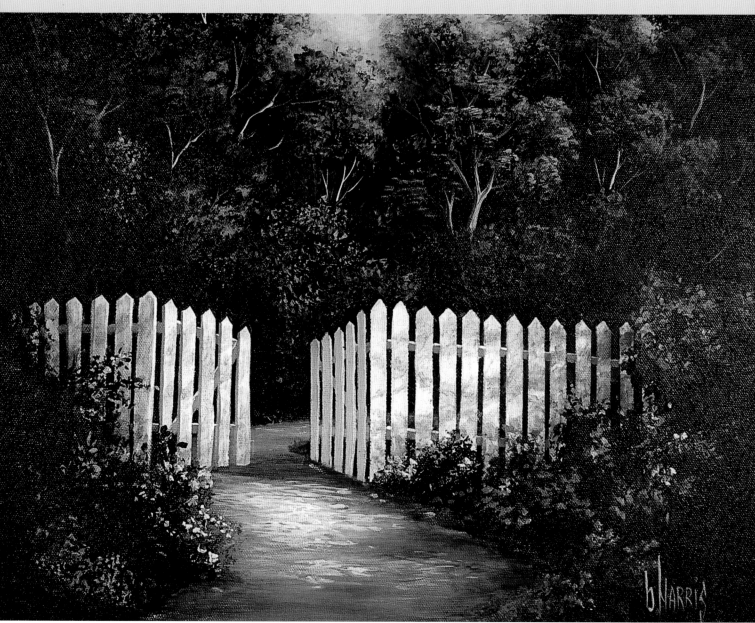

Come On In
14" x 18" (36cm x 46cm)

There are as many ways to paint a subject as there are subjects to paint. This composition is a perfect example. On television, I showed how to add the sky after the foliage shapes were established. For this book, I have reversed the process. You will see that the finished product looks the same. This is especially good to learn, because as your painting progresses, you may not always be satisfied with your first strokes. My demonstrations of applying the sky both before and after the foliage show that even if you are not satisfied with your sky when your painting is complete, you can go back and repaint it, concealing the first sky application.

Materials

Acrylic Colors Burnt Sienna, Burnt Umber, Cadmium Red Medium, Cadmium Yellow Medium, Cerulean Blue, Dioxazine Purple, Hooker's Green, Magenta, Mars Black, Phthalo Yellow Green, Titanium White, Ultramarine Blue, Yellow Ochre

Mediums Clearblend and Whiteblend

Brushes Nos. 4, 8 and 12 bristle flats, ¼-inch (6mm) sable/synthetic flat, No. 2 liner, 1½-inch (38mm) hake or ¾-inch (19mm) mop, ½-inch (12mm) comb, ⅜-inch (10mm) sable/synthetic angle, No. 2 fan, Tapered painting knife, Natural sea sponge

Pattern Enlarge the pattern (page 97) 200 percent.

Other 14" x 18" (36cm x 46cm) stretched canvas, Aerosol acrylic painting varnish, Black and white graphite paper, Masking tape, Paper towels, Stylus

Color Mixtures

Before you begin, prepare these color mixtures on your palette.

Peach	Whiteblend + a touch each of Cadmium Red Medium and Cadmium Yellow Medium
Light Cerulean Blue	10 parts Whiteblend + 1 part Cerulean Blue
Medium Gray-Green	2 parts Dark Blackish Green + 1 part Light Cerulean Blue
Dark Blackish Green	3 parts Hooker's Green + 1 part Payne's Gray + 1 part Dioxazine Purple + I part Mars Black
Off–White	Whiteblend + a speck of Yellow Ochre
Leaf Green	Phthalo Yellow Green + various amounts of Dark Blackish Green
Blue-Green	1 part Phthalo Yellow Green + 1 part Cerulean Blue + 1 part Whiteblend
Celery	3 parts Light Cerulean Blue + 1 part Phthalo Yellow Green + 1 part Whiteblend
Lime Green	Phthalo Yellow Green + various amounts of Whiteblend
Violet-Gray	10 parts Whiteblend + 1 part Cerulean Blue + 1 part Magenta + a touch of Payne's Gray
Purple Shadow Glaze	10 parts Clearblend + a touch each of Dioxazine Purple and Payne's Gray

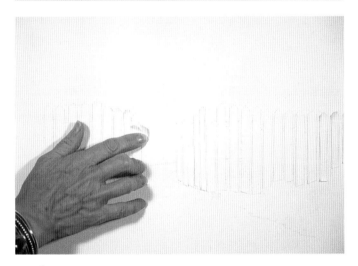

1 Prepare Your Canvas

Transfer the design to your canvas. Cut strips of masking tape to correspond with the width of the upright fence boards and place them on the respective boards.

2 Paint the Sky and Distant Tree Line

Using your no. 12 bristle flat, paint the sky with the Peach mixture. Add the Light Cerulean Blue mixture to the uncleaned brush and stipple irregular foliage shapes along the bottom of the sky to create the distant treetops. Tap to blend slightly.

3 Create the Middle-Ground Foliage

Add the Medium Gray-Green mixture to the uncleaned brush, then stipple treetops beneath the light blue treeline. Add progressively darker treetops lower on the canvas by adding the Dark Blackish Green mixture incrementally to the uncleaned brush. Do not paint solidly; make irregular tree shapes.

4 Establish the Foreground Foliage

Using a no. 12 bristle flat, stipple the Dark Blackish Green mixture in the lower foliage areas, including over the taped fence.

5 Paint the Path

Basecoat, accent then blend the path one section at a time, wet-into-wet. Alternate using your no. 8 flat, angle and multitexture brushes and make all strokes horizontal.

Apply the path basecoating using Burnt Sienna. Add random streaks of Yellow Ochre to the Burnt Sienna. Add Whiteblend highlights to the Yellow Ochre. Strengthen the path shadows with a marbleized mixture of Clearblend, Cadmium Red Medium, Ultramarine Blue and Payne's Gray. Connect the path to the foliage pulling some of the Dark Blackish Green mixture into the edges of the path. Let this dry.

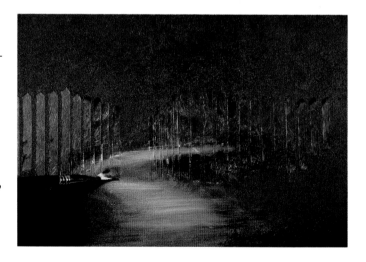

6 Add Path Detail

Using a no. 2 fan, remoisten the path with Clearblend. While still wet, add highlights to the sunlit areas using your comb brush and various values of the brush-mixed Peach mixture. Hold the brush horizontally and apply the paint using short, horizontal strokes. Mix a light yellow with Yellow Ochre, Whiteblend and Titanium White. Use various values of this for the lightest dapples of sunlight. Deepen shadows with Payne's Gray and Dioxazine Purple if needed. Blend the edges of the highlighted and shadowed areas to create a gradual transition. Once this dries, reattach your pattern and transfer the cross braces of the fence, as well as the tree trunks and foliage shapes.

7 Paint Reflected Light on the Foliage

Using the sponge, randomly tap the Medium Gray-Green mixture throughout the foliage area to suggest reflected light.

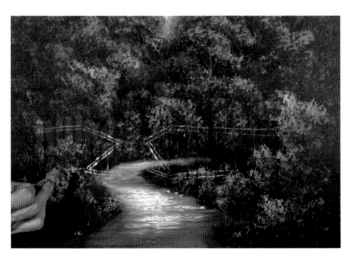

8 Create Foliage Highlights

Using your no. 8 flat and various values of the Leaf Green, Blue-Green, Celery and Lime Green mixtures, stipple highlights on the top and right sides of the foliage shapes, being careful not to cover all the dark areas. Concentrate the brighter highlights in the central area of the foliage and the duller highlights on the trees nearest the canvas edges. Then place lighter highlights along the top and right portions of the duller highlights.

9 *Paint Tree Trunks and Limbs*

Apply tree trunks and limbs in the shadowy areas of the central foliage using a liner double loaded with Burnt Umber on the left and the Peach mixture on the right. Blot the base of the wet tree trunks to make them appear as though they recede into the foliage. For the tree trunks and limbs on the outer portions of the canvas, dull the Peach highlights by adding a touch of Burnt Umber.

10 *Define the Leaves*

With your no. 4 bristle flat and the foliage colors used in previous steps, apply clusters of leaves along the limbs, crossing over the tree trunks. Concentrate the lighter and brighter colors in the central portion of the foliage. Let this dry.

11 *Paint the Fence*

Using the liner and the Violet-Gray mixture, paint the fence braces. Add highlights to the top and right sides of the braces using the Off-White mixture. Let dry; remove the tape. Paint the upright slats to the left side of the gate, as well as the gate on the right side of the path, using the Violet-Gray mixture. Touch up the remaining slats with streaks of the Off-White mixture. Highlight the extreme right edges of the Violet-Gray slats on the fence to the right using the Off-White mixture. Then, paint a thin shadowed edge along the upright Off-White boards on the left gate using a liner and the Violet-Gray mixture. Let dry.

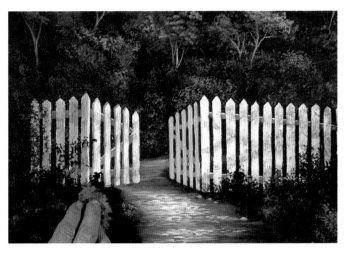

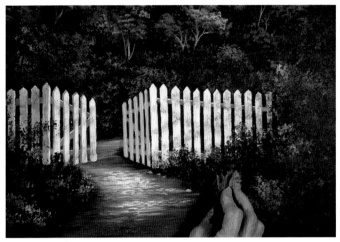

12 *Apply Fence Shadows and Develop the Foreground Shrubs*

Using your fan brush, apply dabs of the Purple Shadow Glaze in random clusters angled across the fence boards. Darken the glaze, adding Payne's Gray and a touch of the Dark Blackish Green mixture for the shadowy area where the shrubs and flower foliage will ultimately overlap the fence. Let this dry.

Apply the shrubs and flower foliage overlapping the bottom of the fence using your sponge and the Dark Blackish Green mixture. Add highlights to this foliage using the same technique and colors as in previous steps. Let this dry.

13 *Add the Flowers*

Be creative in selecting your flower colors. Use any color or combination of colors from your palette. When applying the flower clusters, use a light touch, being careful not to paint the base color or the highlights solidly. Apply the flower's base color with your sponge using pure tube colors or a combination of tube colors. For each flower's respective highlight, add Titanium White incrementally to the base color. When applying the flowers behind the fence, dull the flower's colors by adding a tiny speck of Payne's Gray. For the flowers in front of the fence, randomly apply a few brightly highlighted petals using your sable/synthetic flat.

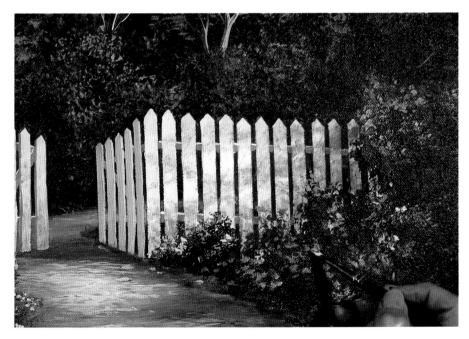

14 *Place the Finishing Touches*

Dab a few detailed leaves in and around the foreground foliage using your sable/synthetic flat and contrasting foliage colors. Touch up areas of your painting as needed. Sign your painting and allow it to dry. Finish it off with acrylic varnish and come on in!

From Whence We Came

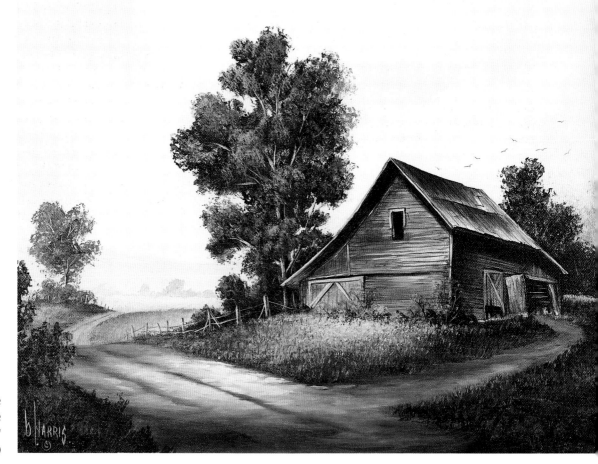

**From Whence
We Came**
14" x 18"
(36cm x 46cm)

People are always asking me where I get the ideas for my paintings. I tell them that ideas are all around us, right there in the everyday things we see, as well as in images from our past.

As I was photographing this barn on the farm of Barb and Jim Johnson in Amboy, Minnesota, Barb was sharing stories of the fun times they'd had around the farm with their children when they were growing up. Sure, I was intrigued with the old, picturesque barn; but what motivated me to paint it was a phrase Barb kept repeating as she spoke so lovingly of her family's history: *from whence we came*.

In this lesson you will learn many techniques to use in your own compositions. You will learn to create clouds that could easily be used in any landscape or transferred to a cityscape. You will learn to create depth in a composition by changing the value, size and shapes of objects. You will also get great practice working with washes to create luminosity, form and volume. Remember, these techniques can be used universally and are not limited to barns. Think of all the scenes from whence you came that these exercises would fit into!

Materials

Acrylic Colors Burnt Sienna, Burnt Umber, Cadmium Red Light, Cadmium Yellow Medium, Dioxazine Purple, Hooker's Green, Payne's Gray, Phthalo Yellow Green, Raw Sienna, Titanium White, Ultramarine Blue

Mediums Clearblend and Whiteblend

Brushes 2-inch (51mm) bristle flat, Nos. 4, 8 and 12 bristle flats, No. 2 liner, 1½-inch (38mm) hake or ¾-inch (19mm) mop, ½-inch (12mm) comb, ⅜-inch (10mm) sable/synthetic angle, No. 2 fan, Tapered painting knife

Pattern Enlarge the pattern (page 98) 189 percent.

Other 14" x 18" (36cm x 46cm) stretched canvas, Adhesive paper, Aerosol acrylic painting varnish, Black transfer paper, Paper towels, Stylus, Ultrafine-point waterproof permanent marker or technical pen

Color Mixtures

Before you begin, prepare these color mixtures on your palette.

Light Blue	8 parts Whiteblend + 1 part Ultramarine Blue + a touch of Payne's Gray
Light Violet	10 parts Light Blue + l part Dioxazine Purple
Light Yellow	Whiteblend + a touch of Cadmium Yellow Medium
Tan	3 parts Whiteblend + 1 part Raw Sienna
Peach	3 parts Whiteblend + 1 part Cadmium Red Light + a of touch Cadmium Yellow Medium
Barn Red	8 parts Cadmium Red Light + 1 part Burnt Sienna + 3 parts Clearblend
Barn Red Shadow	3 parts Barn Red + l part Dioxazine Purple + 1 part Payne's Gray
Dark Brown	1 part Burnt Umber + 1 part Dioxazine Purple +1 part Payne's Gray
Dark Green	2 parts Burnt Umber + 2 parts Ultramarine Blue + 1 part Hooker's Green
Medium Green	l part Light Violet + 1 part Dark Green
Blue-Green	2 parts Ultramarine Blue + 1 part Phthalo Yellow Green + a touch of Whiteblend

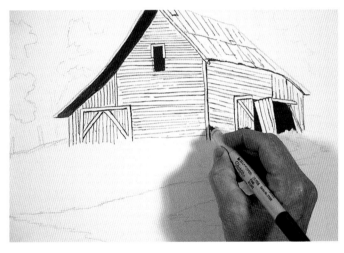

1 Prepare Your Canvas

Transfer the design to your canvas using a stylus and black transfer paper (page 7). Mark the roof and board lines with an ultrafine-point waterproof permanent marker or technical pen. Paint the door openings, cracks and the eave on the front of the barn using your liner or angle brush loaded with the Dark Brown mixture. Let this dry. Prepare a design protector (page 7) and place it over the barn.

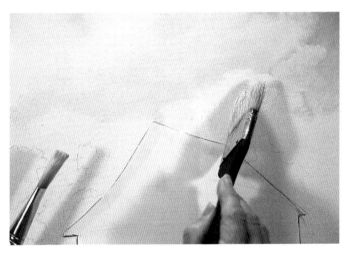

2 Lay in the Sky and Add Foreground Clouds

Paint the sky one section at a time. Apply the Light Blue mixture across the top section of the canvas with the 2-inch (51mm) bristle flat. Paint Whiteblend along the bottom edge of the Light Blue mixture with a no. 12 bristle flat, making the tops of the clouds. Blend with the hake or mop. Work back and forth and downward using the same colors, methods and brushes until the sky and clouds are painted and blended. Touch up or enhance the sky by moistening an area with a no. 2 fan and Clearblend. Add and blend more color over the previous layer. Create soft edges by blending the edge of the paint over the dry sky using a no. 2 fan moistened with Clearblend. Let this dry.

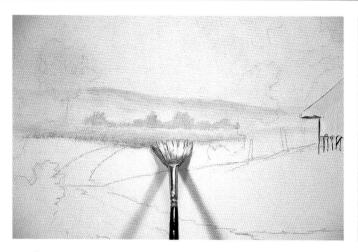

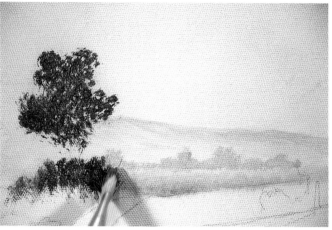

3 Paint the Distant Hills, Tree Line and Meadow

Using your no. 4 bristle flat, paint the top of the distant hills with the Light Violet mixture. Add Whiteblend to the uncleaned brush and paint the lower portion of the hills. Blend with a slight, gentle slope. Add a speck of Payne's Gray to the Light Violet mixture and tap a distant tree line at the base of the mountain range. Holding your no. 2 fan with the handle tilted downward, tap the Light Yellow mixture over the distant meadow. Add a touch of the Medium Green mixture to the uncleaned brush and tap in the valley behind the middle meadow. Tap back and forth between both colors with a clean no. 2 fan to create a gradual transition between the two.

4 Define the Middle-Ground Tree and Surrounding Foliage

Lightly stipple the airy middle-ground tree and foliage beneath it (on the left) using your no. 4 bristle flat and the Medium Green mixture. Tap a hint of grass directly beneath the foliage around the tree using the tip of your comb brush and the Light Yellow mixture. Beneath the grass, tap the Medium Green mixture across the crest of the hill using a no. 2 fan. Hold the brush with the handle tilted downward. Add a touch of Phthalo Yellow Green and Whiteblend to the uncleaned no. 2 fan to paint the center section of the meadow, and tap the Light Yellow mixture in the valley. Blend, tapping a clean no. 2 fan back and forth between the meadow and the valley, creating a gradual transition between colors.

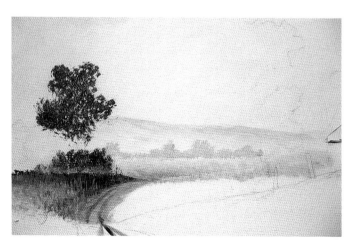

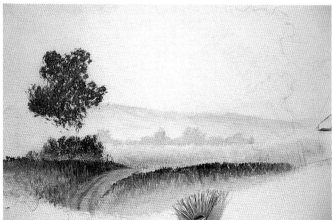

5 Lay in the Distant Road

Using your no. 4 bristle flat to make short horizontal strokes, paint the distant road with the Tan mixture. While still wet, add narrow, slightly darker tracks with a liner and a mixture of the Tan and Dark Brown mixtures. Blend slightly to sink the tracks using a comb brush.

6 Define the Middle Meadow

Holding your no. 2 fan with the handle tilted downward, tap the Medium Green mixture across the crest of the hill. Add a touch of Phthalo Yellow Green and Whiteblend to the uncleaned brush and paint the center section of the meadow. Tap the Light Yellow mixture in the valley and blend as in previous steps.

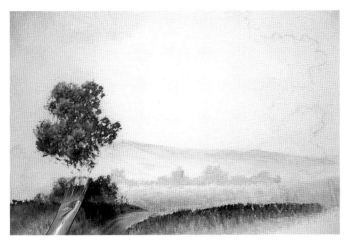

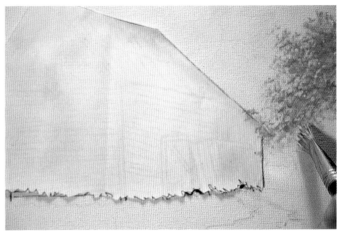

7 Further Develop the Middle-Ground Tree

Double load a no. 4 bristle flat with the Medium Green mixture on the bottom and Phthalo Yellow Green with a touch of Whiteblend on the top. Stipple highlights on the top and left sides of the foliage clusters using the lightened Phthalo Yellow Green, and stipple the Blue-Green mixture on the right side of the foliage clusters to indicate reflected light.

8 Create the Distant Trees to the Right of the Barn

Brush-mix Ultramarine Blue, Whiteblend and a touch of the Dark Green mixture with your no. 8 bristle flat, creating a light blue-gray green. Then, lightly stipple the distant trees behind the right side of the barn.

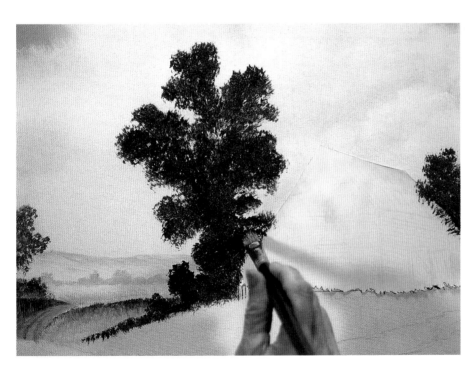

9 Establish Foreground Foliage Behind the Barn

Stipple the airy foliage behind the right side of the barn using your no. 8 bristle flat and a brush-mixture of the Dark Green and Medium Green mixtures. With the same brush, stipple the foreground tree and foliage behind the left side of the barn with the Dark Green mixture. Add Burnt Sienna to the top of your uncleaned brush and randomly stipple into the Dark Green mixture.

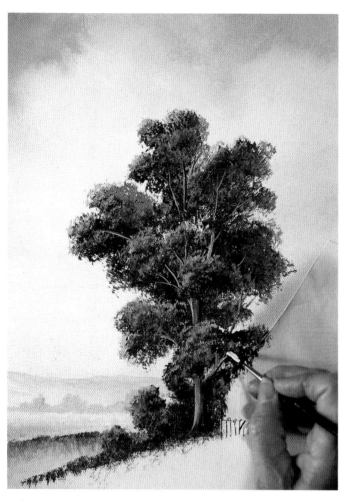

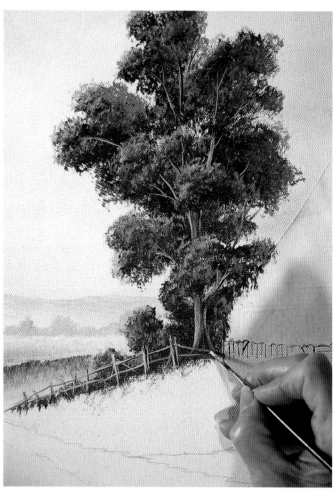

10 *Add Highlights and Draw the Trunks*

Double load your no. 8 bristle flat with the Dark Green mixture on the bottom and Phthalo Yellow Green on the top. Use this brush to highlight the left edges of the foliage on the top and left sides of the tree. Be careful to highlight only the clusters on the left three-fourths of the tree, leaving plenty of darks showing. Add brighter highlights on the top-left sides of some Phthalo Yellow Green leaves by adding a touch of Whiteblend to the mix. Next, stipple reflected light on the right side and in the shadowy areas of the clusters using a clean no. 8 bristle flat and the Blue-Green mixture. Apply the tree trunk with a liner and Burnt Umber. Using the same brush, highlight the central portion of the trunk with the Tan mixture, making short, vertical strokes to suggest the texture of bark. Highlight the left side of the trunk in the same manner using the Peach mixture. Create limbs in the shadowy spaces between foliage clusters using a liner double loaded with thinned Burnt Umber and the Peach mixture. Apply reflected light on the right sides of the trunk and limbs using the same brush and the Light Violet mixture.

11 *Paint the Fence*

Draw the rickety fences using a liner double loaded with soupy Burnt Umber on the right and top sides and the Peach mixture on the left and bottom sides. Let this dry, then remove the design protector.

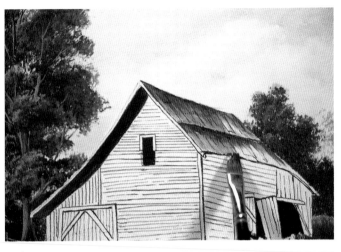

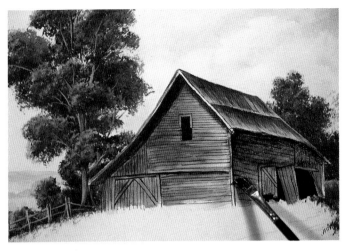

12 Paint the Roof

Beginning with the top section, paint and blend the roof one section at a time, applying multiple thin coats in each area and making your strokes coincide with the slope of the roof. Using a comb brush, cover the bottom half of this section with Clearblend. Cover the top half of the same section with Burnt Sienna, dropping in dabs of Burnt Umber along the top edge to darken. Quickly blend the Clearblend and Burnt Sienna where they meet using your comb brush moistened with Clearblend. Repeat this process to paint the bottom section of the roof. Once this is dry, highlight the edge of the left side of the roof using a liner and a mixture of the Barn Red mixture and White-blend. Add a thin line of the Light Blue mixture along the rear edge of the right side of the roof to suggest reflected light. If your values are correct, the roof will be darkest on top, gradually fading as it moves downward.

13 Paint the Barn

Using your angle brush to stroke in the direction of the wood grain, apply the Barn Red mixture unevenly to one section of the barn at a time. While it's still wet, apply shadows under the eaves and on the right side of the barn with the Dark Brown mixture. Soften the outer edges of the shadows, blending with a clean, dry hake or mop. Allow this to dry, then strengthen the eave shadows and blend the edges with a comb brush moistened with Clearblend. Let your canvas dry before moving on.

14 Add Barn Details

Streak some boards on the front of the barn using a liner and a mixture of Clearblend, Cadmium Red Light and Cadmium Yellow Medium. Blot to subdue. Highlight a few of the boards to the right with the Light Yellow mixture; let dry. Apply the moldings on the front of the barn with a liner and the Light Violet mixture. Add a touch of Burnt Sienna to this mixture for the side moldings. Still using the same brush, add a thin line of the Barn Red Shadow mixture underneath and to the right side of some of the moldings, and touch up cracks and shadows as needed. Add hints of light between the boards inside the rear-door opening using a liner and the Light Blue mixture.

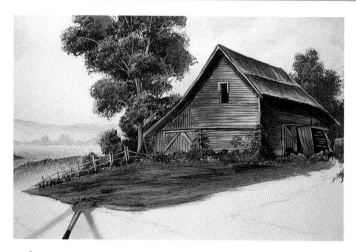

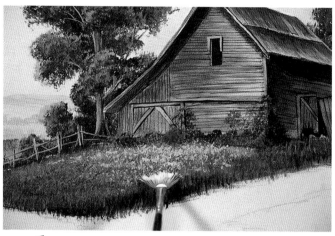

15 Create the Center Foreground Foliage and Grass

Stipple sparse, airy bushes at the base of the barn with the same technique and colors used in step 9. Apply and blend a scruffy basecoat for the grass directly in front of the barn using a no. 2 fan double loaded with the Dark Green mixture on the right and Raw Sienna on the left. While still wet, create the illusion of individual blades of grass, making short, downward, strokes of the Dark Green mixture with a no. 2 fan.

16 Add Highlights and Dandelions

With light, tapping strokes of the fan brush, apply Phthalo Yellow Green highlights in the central grass area beneath the barn. Now with a clean no. 2 fan, add the Blue-Green mixture in the shadowy areas to indicate reflected light. Lightly tap dandelions in the central grass in front of the barn with a clean no. 2 fan and a mixture of Cadmium Yellow Medium and a touch of the Light Yellow Mixture. Let dry.

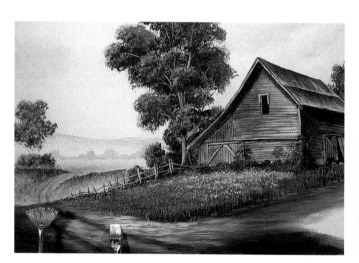

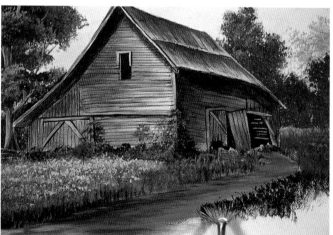

17 Paint the Foreground Road and Path

Using your no. 8 bristle flat, brush-mix various values of Burnt Umber and Whiteblend and paint the foreground road and path. While still wet, add shadows and ruts with your comb brush and the Dark Brown mixture. Slightly blend the wet tracks into the road using the corner of a no. 2 fan. Then apply horizontal patches of the Tan and Peach mixtures in the sunlit areas of the path to suggest highlights. Lightly blend the edges with a comb brush moistened with Clearblend.

18 Add Highlights and Reflected Light to the Foremost Grass

Stipple the foremost grass using a no. 2 fan and a no. 8 bristle flat with the Dark Green mixture. Add only a hint of Phthalo Yellow Green highlights in the grass nearest the path. Stipple reflected light in the remaining foreground foliage with the Blue-Green mixture.

19 *Lay in the Foremost Foliage*

Stipple the foremost foliage in the left corner using your no. 8 bristle flat and the Dark Green mixture. Let this dry, then lightly stipple reflected light on the top-right sides of some of the clusters with the Blue-Green mixture.

20 *Add Further Details*

Add additional twigs, limbs and tree trunks as needed using a liner double loaded with Burnt Umber on the right and the Peach mixture on the left. Should you need to touch up areas of the sky, ground or barn, first moisten the entire area with Clearblend, and then add the appropriate color. Blend the edges of the added color with a Clearblend-moistened brush so that no hard lines remain. Let dry.

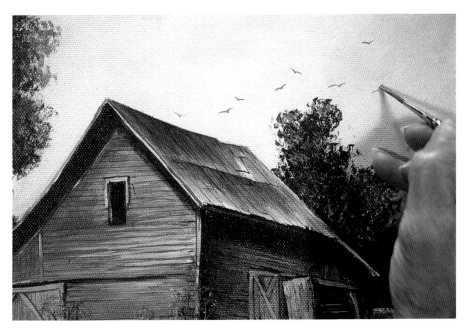

21 *Paint the Birds*

Add the birds using your liner and a brush-mixture of the Light Violet mixture with a touch of Payne's Gray. Sign your painting and let it dry, then spray with aerosol acrylic painting varnish. Now you can kick back and reminisce about the place from whence you came!

By the Dock of the Bay

This scene is characteristic of many seaside towns stretching up the northeast coast. Built by local craftsmen using unevenly chiseled natural stones found in the area, these docks have weathered many storms and provided a safe haven for several generations of boaters.

In this lesson you will extend the French matting technique (page 7) to encompass a colored border with a double-matted look. You will learn to block in dark shadows, then smudge accent colors around the shadows to create form and depth. In addition, you will use glazes to add glowing colors and sink the reflections deep in the water. This will be a fun exercise for you.

Thanks to Leo Christmas, an artist friend of mine, for sharing his ideas and the basic composition for this lesson.

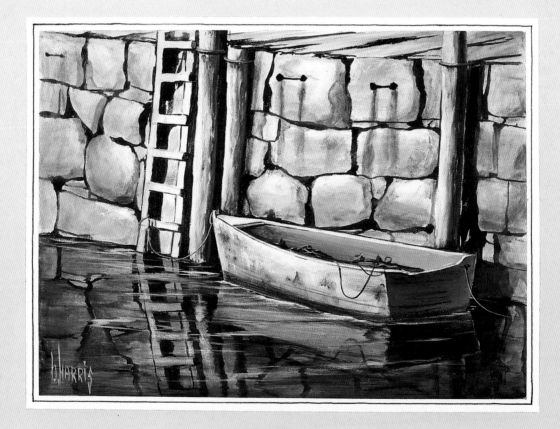

By the Dock of the Bay
16" x 20" (41cm x 51cm)

Materials

Acrylic Colors Burnt Sienna, Cadmium Red Light, Cadmium Yellow Medium, Dioxazine Purple, Mars Black, Phthalo Blue, Phthalo Yellow Green, Yellow Ochre

Mediums Clearblend and Whiteblend

Brushes Nos. 6, 8 and 12 bristle flats, No. 2 Liner, ½-inch (12mm) comb, ⅜-inch (10mm) sable/synthetic angle, Tapered painting knife

Pattern Enlarge the pattern (page 99) 161 percent.

Other 16" x 20" (41cm x 51cm) stretched canvas, 16" x 20" (41cm x 51cm) mat template, ½-inch (12mm) masking tape, Aerosol acrylic painting varnish, Black transfer paper, Paper towels, Shipping tape, Small containers for glazes, Stylus, Ultrafine-point waterproof permanent marker or technical pen

Color Mixtures

Before you begin, prepare these color mixtures on your palette. Mix glazes in small disposable containers.

Pastel Yellow	30 parts Whiteblend + 1 part Cadmium Yellow Medium
Light Gray	30 parts Whiteblend + 1 part Mars Black
Warm Gray	Light Gray + a touch of Mars Black + a touch of Burnt Sienna
Violet-Gray	Warm Gray + a touch of Dioxazine Purple + a speck of Phthalo Blue
Dusty Blue-Gray	1 part Dark Blue-Green Glaze (see below) + 1 part Whiteblend
Off-White	2 parts Whiteblend + 1 part Pastel Yellow
Dark Shadow Glaze	20 parts Clearblend + 1 part Mars Black
Dark Blue-Green Glaze	30 parts Clearblend + 1 part Mars Black + 1 part Phthalo Blue + a speck of Dioxazine Purple
Golden Glaze	30 parts Clearblend + 1 part Yellow Ochre
Green-Yellow Glaze	Golden Glaze + a touch of Phthalo Yellow Green

1 Create a Border

Place the canvas on a flat surface, then align a 16" x 20" (41cm x 51cm) mat template on top of it. Hold the mat template securely in place and draw a rectangle on the canvas by dragging an ultrafine-point waterproof permanent marker or technical pen along the inside edges of the template opening. Remove the template and allow the ink to dry.

2 Tape the Border

Lay masking tape over the lines so the line runs down the middle of the tape. Miter the corners of the tape where the pieces overlap.

3 Basecoat Outside and Inside the Taped Border Line

Use the 2-inch (51mm) bristle flat to paint the border outside the taped rectangle with the Light Gray mixture. Paint the Pastel Yellow mixture inside the border using a 2-inch (51mm) flat. Let dry and reapply if there are visible streaks or uneven color.

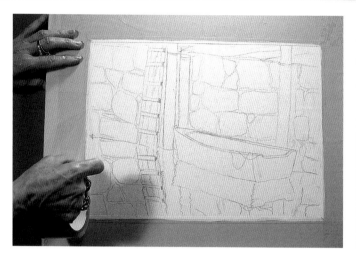

4 Transfer the Design and Tape the Outside Border

Put black transfer paper behind the pattern and tape the pattern securely in place. Transfer the design by tracing over the lines with a stylus (page 7). Cover the outside border with wide shipping tape to protect the gray border while painting. Overlap the outside edge of the masking tape with the shipping tape.

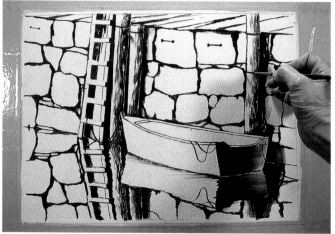

5 Paint the Dark Shadow Patterns

In the next steps, every time you paint something above the water, repeat using the same colors and technique to paint its reflection in the water.

Paint the dark shadow patterns between the rocks, along the pilings, ladder and boat with thinned Mars Black, using the liner, angle or comb brush. When painting the reflection patterns, make some of the lines zigzag slightly, creating a shimmery appearance. Let dry.

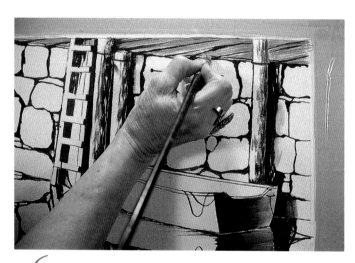

6 Paint the Deck Planks

Thin the Warm Gray mixture and load it onto the comb brush; streak it across the deck at the angle of the dark lines. Be careful not to paint solidly so you can get the texture of the wooden planks.

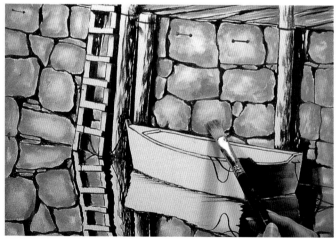

7 Contour and Color the Rocks

Apply the Warm Gray mixture on and around the rocks with the no. 6 bristle flat. Smudge the edges of the paint with your finger or the no. 8 bristle flat; this creates soft, uneven coloration and soft edges to give the rocks form and volume. Paint, then smudge the color on one rock before moving to the next rock. Don't paint too opaquely; allow the Pastel Yellow basecoat to glow through and remain visible in areas on the rocks. Let dry.

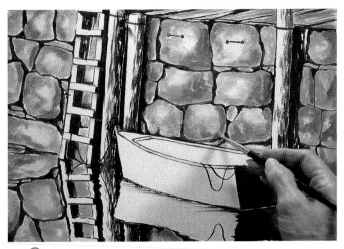

8 _Embellish the Rocks_

Darken the values of the Warm Gray and Violet-Gray mixtures by adding a touch more Mars Black and Burnt Sienna to them. Paint those colors on the rocks, then smudge them. Dry between each color and build several translucent layers.

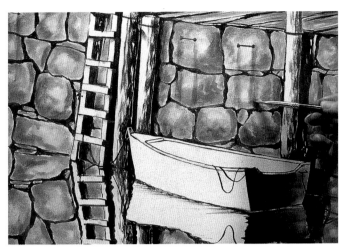

9 _Add Warmth and Rust_

Apply dashes of the Golden Glaze over some of the rocks, ladder and pilings. Smudge the edges, creating a faint warm glow. Brush-mix Cadmium Red Light with a touch of Clearblend and apply the color to random rocks in the same manner. With the liner and the same mixture, streak some rusty stains down over the rocks from the cleats. Let dry. Apply the translucent, Green-Yellow Glaze on some of the lower rocks, ladder and pilings to create a wet appearance. Let dry.

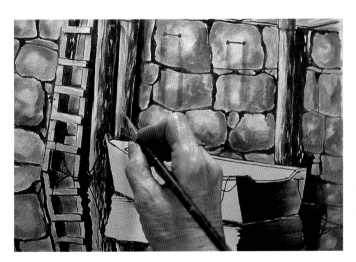

10 _Paint the Pilings_

Hold the comb brush vertically and paint the gray rock colors (from steps 7 and 8) on the pilings using short, choppy strokes. Place the darker colors on the right side. Soften the left edge to create a rounded appearance. Let dry. Use the liner to paint reflected light with a hint of the Violet-Gray mixture on the right side of the piling; this separates the pilings from the shadow on the rock wall behind it.

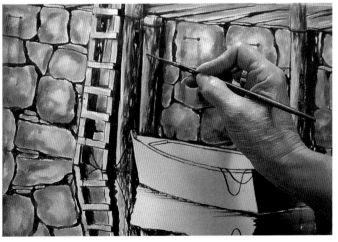

11 _Add the Brackets and Rust Stains_

Use the liner to paint the rusty brackets that attach the pilings to the dock with Cadmium Red Light and a touch of Whiteblend. Touch up the shadow with the Dark Shadow Glaze. Let dry. Moisten the pilings under the brackets with water. Add dabs of Burnt Sienna, Cadmium Red Light and the Dark Shadow Glaze randomly on the moist pilings using the point of the liner. Drag the colors down with a clean, wet liner.

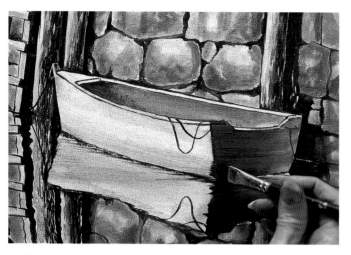

12 Block In the Boat

Using an angle brush, apply the Violet-Gray mixture inside the boat. Paint the lower shadowed area with Mars Black and a touch of Phthalo Blue; blend. Streak the outside back of the boat with the Violet-Gray mixture. Streak the lower part of the side with the Dusty Blue-Gray mixture. Add smudges and streaks of the Light Gray and Warm Gray mixtures on the side and faintly on the rear of the boat.

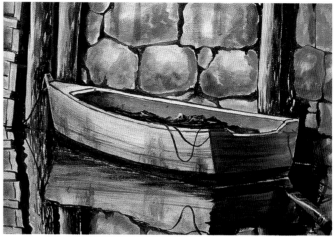

13 Embellish the Boat

Create nets and lines inside the boat with Mars Black. Streak and dab folds and netting using the liner with values of the Warm Gray mixture. Wet the side of the boat with a no. 6 bristle flat. Add dabs of Burnt Sienna, Cadmium Red Light and the Dark Shadow Glaze to the point of the liner, and add the colors randomly on the side. Paint a rusty band around the bottom of the boat with a dull mixture of Burnt Sienna and a touch of the Dark Shadow Glaze. Drag the color down with a clean, wet liner. Repaint the cleats with Mars Black. Touch up the top edges of the boat with the Pastel Yellow and Off-White mixtures. Use the liner to paint dark streaks between the wooden planks on the back and side with the Dark Shadow Glaze. Touch up the lines tying the boat to the dock with a double-loaded liner using Mars Black and the Off-White mixture. Let dry.

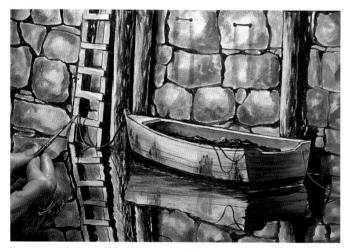

14 Detail the Ladder

Touch up and add colors from the rocks and boat to the ladder, making the colors harmonious with the surroundings. Blot and smudge to create soft edges between colors.

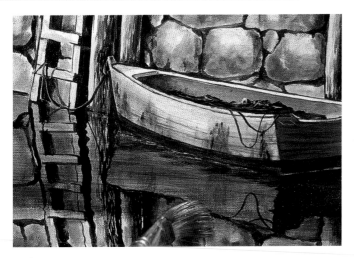

15 Glaze the Water

Paint the water with the Dark Blue-Green Glaze, stroking horizontally with the no. 12 bristle flat.

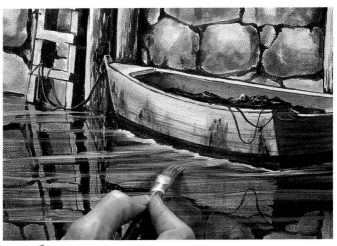

16 Add Ripples Around the Boat

Use the liner and the Light Gray mixture to stroke water lines across the wet glaze. Stroke the edges of the water-lines lightly with the comb brush to soften them. Add a touch of Whiteblend to lighten the color and add a broken ripple line around the side of the boat. With a clean comb brush, pull the ripple line across the water, away from the boat.

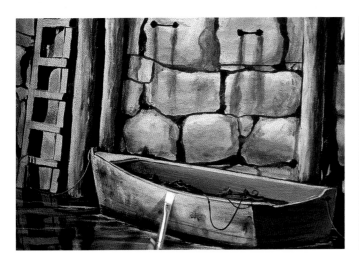

17 Add Additional Shadows and Highlights

Strengthen shadows as needed and add some dirty streaks dripping down under the cleats with the Dark Shadow Glaze, then smudge. Drybrush (load your brush with very little paint and lightly skim the surface of the canvas) a touch of the Off White mixture on a protruding portion of a few rocks in the center and top areas. Add a few touches on the pilings and ladder if needed. Sign and dry your painting. Remove the tape.

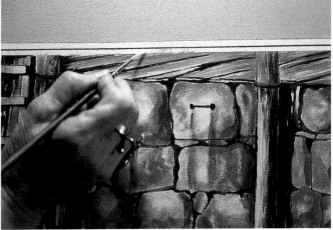

18 Add the Final Details

Touch up any seepage with the liner and Whiteblend. Dry. Spray your painting with an aerosol acrylic painting varnish and go sit by your dock of the bay.

Along the Water's Edge

Standing over 3 feet (91cm) tall, with a wingspan of up to 55 inches (140cm), the Great Heron is one of the largest birds in the heron family. They live in mudflats, tidal shallows and marshes worldwide, and help to preserve the balance of nature by eating fish, lizards, frogs, crayfish, small rodents and insects. These elegant white birds with S-shaped necks; long, yellow, sharp bills; and long, lanky, black legs are equally graceful wading through shallow waters or flying with slow, serene wing beats.

This bird provides a great introduction to painting wildlife. In painting this bird you will learn to layer strokes to create the appearance of thick plumes of feathers, building one layer upon another. You will also learn to use value changes to create form and volume as well as how to create luminosity with the application of complementary pink and teal reflected light.

We have lots to learn, so let's get started.

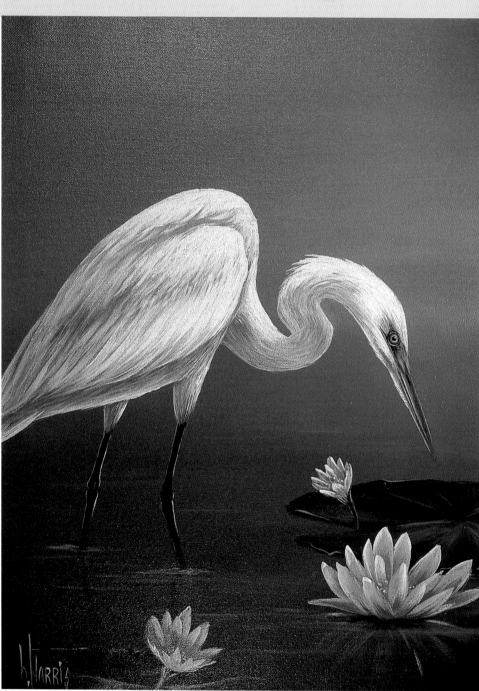

Along the Water's Edge
20" x 16" (51cm x 41cm)

Materials

Acrylic Colors Burnt Sienna, Cadmium Red Medium, Cadmium Yellow Medium, Cerulean Blue, Dioxazine Purple, Hooker's Green, Payne's Gray, Titanium White, Ultramarine Blue, Yellow Ochre

Mediums Clearblend and Whiteblend

Brushes 2-inch (51mm) bristle flat, ¼-inch (6mm) sable/synthetic flat, No. 2 round, No. 2 liner, 1½-inch (38mm) hake or ¾-inch (19mm) mop, ½-inch (12mm) comb, ⅜-inch (10mm) sable/synthetic angle, No. 2 fan, Tapered painting knife, Natural sea sponge

Pattern Enlarge the pattern (page 100) 200 percent.

Other 20" x 16" (51cm x 41cm) stretched canvas, Aerosol acrylic painting varnish, Black and white transfer paper, Paper towels, Stylus

Color Mixtures

Before you begin, prepare these color mixtures on your palette.

Off-White	20 parts Titanium White + a speck of Cadmium Yellow Medium
Bright Peach	10 parts Whiteblend + 2 parts Cadmium Red Medium + 1 part Yellow Ochre
Wheat	1 part Yellow Ochre + 1 part Whiteblend
Lemon Yellow	3 parts Cadmium Yellow Medium + 1 part Whiteblend
Hunter Green	2 parts Payne's Gray + 1 part Hooker's Green
Yellow-Green	3 parts Yellow Ochre + 1 part Hunter Green
Dark Brown	1 part Burnt Sienna + 1 part Payne's Gray + a speck of Dioxazine Purple
Medium Brown	2 parts Yellow Ochre + 1 part Dioxazine Purple
Violet-Gray	10 parts Whiteblend + 3 parts Ultramarine Blue + 1 part Dioxazine Purple + a touch of Payne's Gray
Light Teal	1 part Whiteblend + 1 part Cerulean Blue
Navy	40 parts Payne's Gray + 20 parts Ultramarine Blue + 1 part Whiteblend

1 Lay In the Background

Beginning at the bottom of your canvas, quickly apply the background using your 2-inch (51mm) bristle flat and the Navy mixture. Add Whiteblend to this mix periodically, making the background gradually lighter as you work up the canvas. Continue the background, adding the Bright Peach mixture to your uncleaned brush to create a mauve hue. Add more of the Bright Peach mixture as you move upward, making the top a lighter shade of pink. Blend the background with a clean, dry 2-inch (51mm) bristle flat and smooth brush marks using your hake or mop. Let dry. Transfer the egret, lily pads and flowers with white transfer paper.

2 Define the Bird's Eye and Beak Base

Using a no. 2 liner, paint the top half of the bird's eye the Wheat mixture and the bottom half the Lemon Yellow mixture. Blend with your hake or mop. Then with a no. 2 liner, paint the eye rings with the Wheat mixture and the beak with the Yellow Ochre mixture. Highlight the beak with various values of Yellow Ochre and Whiteblend, followed by the Lemon Yellow mixture, using a no. 2 round. Shadow the beak with the Medium and Dark Brown mixtures, blending the colors while wet. Apply thin highlights along the inside edges of the beak with a liner and the Lemon Yellow mixture, leaving some shadow in between. Let this dry.

3 Add Details to Eye and Beak

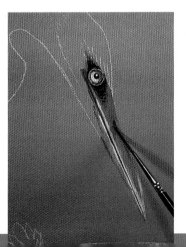

Paint the pupil Payne's Gray using a liner. Paint eye ring shadows, shadows around the eye area, and the nostril with an ink-like consistency of Payne's Gray. Add a catchlight of Whiteblend on the pupil (in the 11 o'clock position) using a liner.

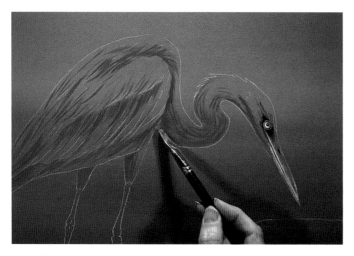

4 Begin Establishing Feathers

Using your comb brush and the Violet-Gray mixture, create feathers in the shadowy areas of the bird's body. Adjust the value as needed so the feathers are slightly darker than the base color in each area. Use a liner for greater control along the outer edges and in tight places like the neck and head. Add a few additional feathers using your comb brush and a medium blue hue made with the Navy mixture and Whiteblend. Don't paint solidly; leave some background color showing through.

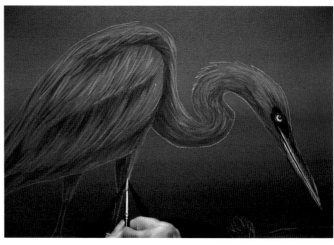

5 Create Additional Layers

With your comb brush, add fullness to the bird's body by creating additional layers of feathers using brush-mixed colors closely matching the mauve background color at the top of your canvas. Lighten your Violet-Gray mixture with Whiteblend and continue layering feathers over the entire body.

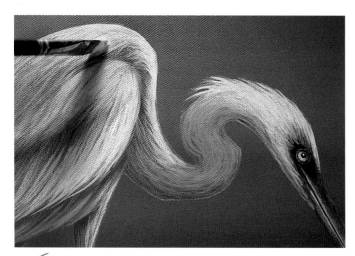

6 Add Highlights

Apply the first layer of highlights on the feathers in sunlit areas using your comb brush and the Off-White mixture. Again, use your liner in small areas or tight places. Tone the Off-White mixture with a touch of the Violet-Gray mixture to create the feather highlights that overlap into the medium-value areas.

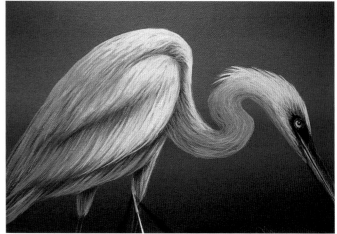

7 Continue Feather Development

Sparingly place random, contrasting strokes in the shadowy areas and areas of medium light using your comb brush and a mixture of the Off-White and Bright Peach mixtures. Follow this with streaks of the Light Teal mixture, being careful not to paint solidly.

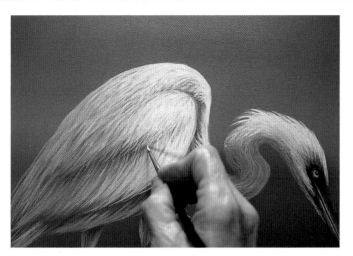

8 *Add Final Details to the Feathers*

Using your liner or no. 2 round, add final details to the feathers with the Off-White mixture and any other feather colors you choose. Make your strokes small, overlapping harsh lines or spaces between feathers to give a softer appearance.

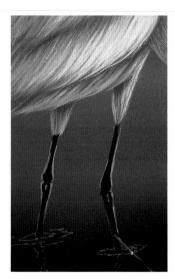

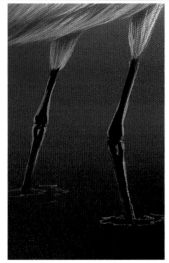

9 *Define the Bird's Legs*

Paint the legs using Payne's Gray and a liner. Let dry. Apply thin, broken lines of Bright Peach mixture along the right edges of the legs. Add reflected light on the left side of the legs in the same manner, using the Light Teal mixture with a touch of the Violet-Gray mixture.

10 *Create the Leg Reflections*

Using a clean, wet sponge, moisten the area beneath the bird and remove the tracing of the leg reflections. Then add Clearblend to this area. While wet, use a liner and Payne's Gray to paint the reflections. Distort the reflections by making short, horizontal strokes across the wet paint, alternating the direction of your brush to create a zigzag pattern.

11 *Develop the Lily Pads*

Paint, highlight and blend each lily pad one section at a time using the wet-into-wet technique. Paint the far side of the most distant section of the lily pad using the Hunter Green mixture and your angle brush. While wet, add streaks of the Yellow-Green mixture using your comb brush. Likewise, add streaks of the Light Teal and Hunter Green mixtures to suggest reflected light. Add Burnt Sienna to your uncleaned brush and streak randomly along the outside edge, pulling the color slightly inward. Lightly blend with a clean, dry comb brush. Repeat for the front side, applying more highlight along the crest of the leaf. Let this dry. Paint the foreground lily pad in the same manner.

12 Define the Lily Pad Edges

Paint the underside of the lily pads' curled edges using a
no. 2 liner and the Hunter Green mixture. Use a liner and
a mixture of the Light Teal and Hunter Green mixtures to
highlight the edge of the curls.

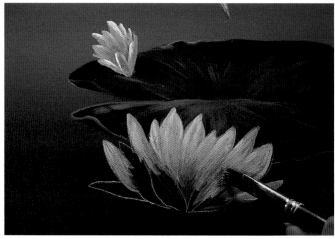

13 Begin the Water Lilies

Paint the tips of "far side" petals using the angle brush
loaded with the Bright Peach mixture. Add the Navy mix-
ture to your brush to create a light value of blue-gray for
the center of the flower's shadow. Blend by stroking paral-
lel to the outside edges of the petals with the comb brush.
Let this dry.

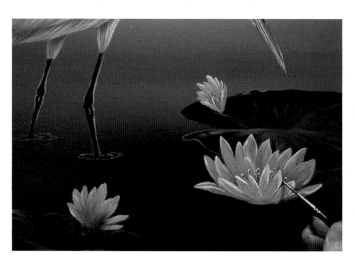

14 Continue Developing the Petals

Repeat step 13 to create the petals on the front of the
water lilies, placing the shadow along the calyx or the edge
of the water. Highlight the tips and edges of some petals
using your liner and a brush mixture of the Off-White and
Bright Peach mixtures. Let dry.

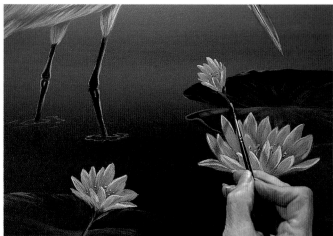

15 Paint the Calyx and Stems

Paint the calyx and stems using a liner double loaded with
the Hunter Green and Lemon Yellow mixtures. Tap a few
stamen dots inside the throat of each flower using the side
tip of a liner double loaded with the Dark Brown mixture
on the bottom and the Wheat mixture on the top. Add a
touch of the Lemon Yellow mixture on the top of some
stamen dots.

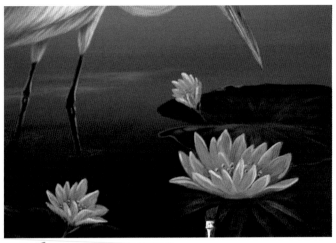

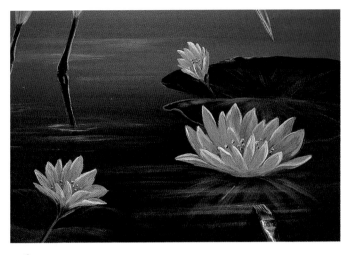

16 *Paint the Flower's Reflection*

Using your 2-inch (51mm) bristle flat and Clearblend, moisten the water area below the large flower. Apply a faint reflection directly beneath the flower using your angle brush and the colors used to paint the flowers. Darken the shadow at the base of the flower with the Navy mixture. Slightly blend with a comb brush and let this dry.

17 *Paint Shimmering Waterlines*

Moisten the entire area below the bird using your 2-inch (51mm) bristle flat and Clearblend. While still wet, apply randomly-spaced, horizontal shimmers throughout the water using your liner with Light Teal and traces of Violet-Gray. Blend the edges of each shimmer horizontally outward using a comb brush moistened with Clearblend. Add an elongated, oval-shaped shimmer around each of the bird's legs using your liner brush. Blend as before.

18 *Add Finishing Touches*

Apply Clearblend over the flowers where reflected light might strike using a comb brush. Streak the Light Teal mixture on the leading edge of a few flower petals and stems using your liner. Soften the reflected light in some areas with a round brush moistened with Clearblend. With the same brush, moisten the stems and calyxes with Clearblend and add a mixture of the Light Teal and Hunter Green mixtures. Indicate holes in the lily pads with dabs of Payne's Gray, then sign your painting. Once it is thoroughly dry, spray it with aerosol acrylic painting varnish. Now you can take a peaceful stroll along the water's edge. Maybe you'll spot one of these beauties!

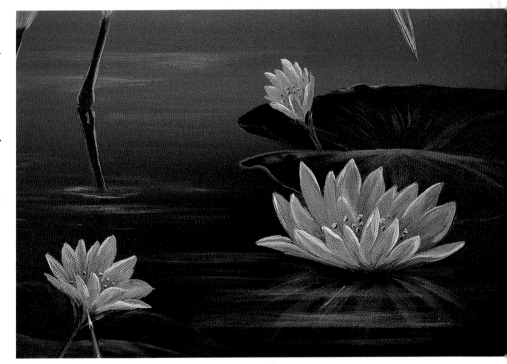

Approaching St. Augustine

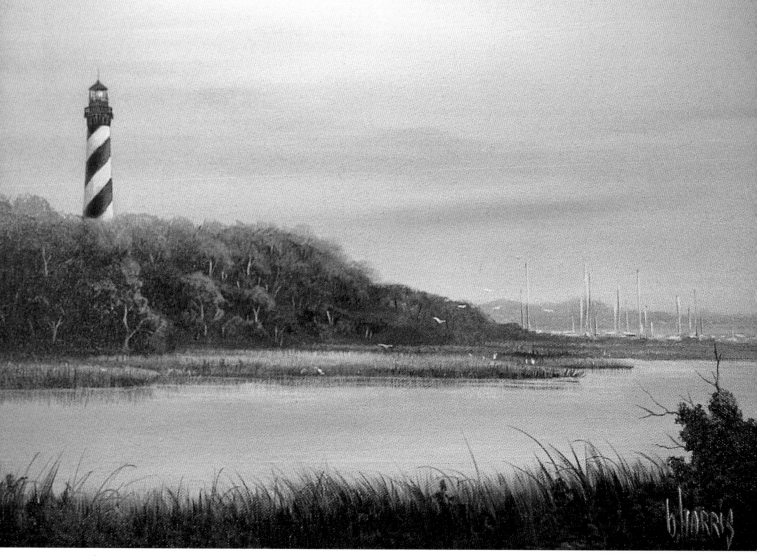

Approaching St. Augustine
16" x 20" (41cm x 51cm)

St. Augustine was founded forty-two years before the English colony at Jamestown, Virginia, and fifty-five years before the Pilgrims landed on Plymouth Rock. Although St. Augustine was destroyed many times by fire and pirates, its residents never gave up, rebuilding and maintaining a continuous settlement on its pristine location, making it the oldest permanent European settlement on the North American continent. Located in northeast Florida, St. Augustine is affectionately known as our nation's oldest city.

This scene, approaching St. Augustine from a southern waterway, offers you a painter's smorgasbord. You will learn to create sky using both warm and cool colors, to depict rolling hills and flat marshland, water, marsh grass, foliage, boats and birds, as well as how to compose a lighthouse.

Materials

Acrylic Colors Burnt Umber, Cadmium Red Medium, Hooker's Green, Mars Black, Phthalo Yellow Green, Ultramarine Blue, Yellow Ochre

Mediums Clearblend and Whiteblend

Brushes 2-inch (51mm) bristle flat, Nos. 4, 8 and 12 bristle flats, ¼-inch (6mm) sable/synthetic flat, No. 2 round, No. 2 liner, 1½-inch (38mm) hake or ¾-inch (19mm) mop, ½-inch (12mm) comb, ⅜-inch (10mm) sable/synthetic angle, No. 2 fan, Tapered painting knife,

Pattern Enlarge the pattern (page 101) 154 percent.

Other 16" x 20" (41cm x 51cm) stretched canvas, 2" (51mm) shipping tape, Aerosol acrylic painting varnish, Black and white transfer paper, Paper towels, Stylus

Color Mixtures

Before you begin, prepare these color mixtures on your palette.

Pale Pink	40 parts Whiteblend + l part Cadmium Red Medium
Pale Yellow	30 parts Whiteblend + 1 part Yellow Ochre
Wheat	Pale Yellow + a touch more Yellow Ochre
Light Blue-Gray	40 parts Whiteblend + 2 parts Ultramarine Blue + 1 part Burnt Umber
Violet-Gray	2 parts Light Blue-Gray + 1 part Pale Pink
Dusty Rose	5 parts Whiteblend + 2 parts Burnt Umber + 1 part Cadmium Red Medium + 1 part Ultramarine Blue
Dark Brown-Green	2 parts Hooker's Green + 3 parts Burnt Umber + 1 part Cadmium Red Medium + 1 part Ultramarine Blue
Gray-Green	Light Blue-Gray + various amounts of Dark Brown-Green

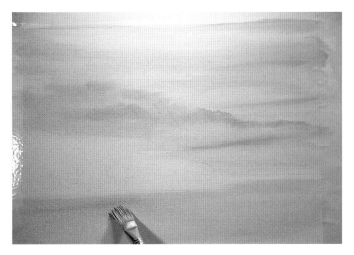

1 Transfer the Pattern and Paint the Sky and the Foreground Water

Tape a border around your canvas with 2-inch (51mm) shipping tape. Transfer your pattern (page 7) with black transfer paper, omitting the lighthouse, birds and boats. Scrub briskly to apply a generous application of Whiteblend over the sky with the 2-inch (51mm) bristle flat. Using the same brush, apply streaks in the top portion of the sky with the Pale Yellow mixture. Add the Pale Pink mixture to the uncleaned brush and apply horizontal streaks in the lower portions of the Pale Yellow area and the lower portions of the sky, using less color closest to the horizon. Apply streaks through the sky with the same brush and the Light Blue-Gray mixture, making some streaks more prominent and cloud shaped on the top side. Blend unwanted harsh streaks first with a no. 12 bristle flat; complete the final blending with the mop. With a clean 2-inch (51mm) bristle flat, apply Whiteblend over the water. Add streaks with the Pale Yellow and Pale Pink mixtures in the lower portions of the water with a 2-inch (51mm) bristle flat and streaks of the Light Blue-Gray mixture along the marsh. Blend as before.

2 Add the Distant Hillside and Water

Stipple the distant hillside using the no. 8 bristle flat with the Light Blue-Gray mixture. Add a touch of the Pale Pink mixture to the top of the brush and tap a subtle texture on the hillside, leaving the hill predominantly blue-gray. Use a clean no. 8 bristle flat to paint the distant water area with a brush mixture of the Pale Pink mixture lightened slightly with a touch of Whiteblend. Hold the comb brush horizontally and add faint streaks of the Light Blue-Gray mixture across the water. Blend, leaving the color a grayed pale pink.

3 *Add the Foliage on the Foreground Bluff*

Stipple the foliage on the foreground bluff using the no. 8 bristle flat. Start along the top with the Gray-Green mixture and add a touch more of the Dark Brown-Green mixture incrementally as you stipple foliage lower on the hillside, ending with mostly dark brown-green along the bottom.

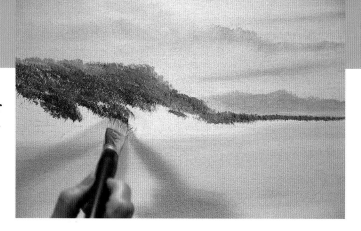

4 *Paint the Bluff Dirt and Sandbars*

Paint the dirt on the bluff using the comb brush with the Dusty Rose mixture, creating trails through the foliage. Add values of the Gray-Green mixture that you used in step 3 to a no. 8 bristle flat bristle; alternate back and forth with them to connect and intertwine the foliage and dirt. Paint sandbars horizontally with the Dusty Rose mixture along the marsh.

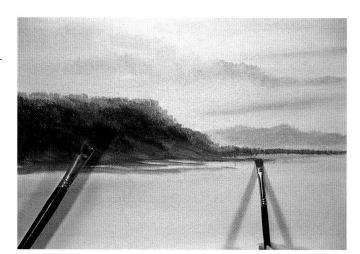

5 *Add the Middle-ground Grass*

Paint the grass, beginning with the most distant area between the distant and foreground water. Alternate applying roots with the Gray-Green mixture on the no. 2 fan and highlights on top of a couple of rows of the distant marsh grass with the Pale Yellow mixture using the comb brush. Make the vertical strokes no more than ⅛ inch (10mm) high. Alter the colors and lengthen the strokes as you progress forward to create interest as well as depth. Alternate touches of the Dark Brown-Green mixture and/or Burnt Umber to darken the shadow. Vary the value of the Pale Yellow highlight by adding Whiteblend for lighter grassy patches or the Wheat mixture for darker areas. Make the foremost middle-ground marsh grass about ½ inch (12mm) tall with the roots as dark as the lower part of the hillside.

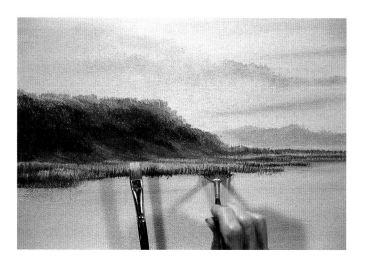

6 *Paint the Grass Reflections*

Moisten the water area underneath the marsh with the 2-inch (51mm) bristle flat, then stroke downward with the no. 2 fan using the Dark Brown-Green mixture. Add a faint reflection of the highlight on the foremost sandbar's grass reflection using the Pale Yellow mixture loaded on the comb brush. Let dry.

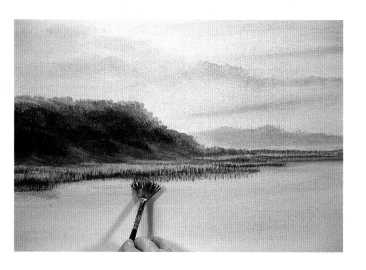

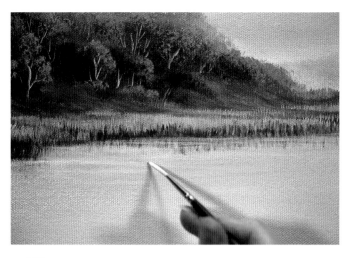

7 Create the Waterlines

Moisten foreground water and the grass reflection using the 2-inch (51mm) bristle flat and Clearblend. Add horizontal waterline streaks randomly across the reflections and water using Whiteblend and the liner. Stroke lightly across the wet waterlines with the tip of a dry comb brush to diffuse the lines.

8 Highlight the Foliage and Add the Tree Details

Highlights: Start applying highlights at the top of the foliage using a no. 4 bristle flat and a mixture of the Gray-Green, Pale Yellow and a speck of the Dark Brown-Green mixtures. Add a touch each of Yellow Ochre and Dark Brown-Green to the former mixture for the central and lower areas. Create a richer and purer tint by adding the Wheat and Pale Yellow mixtures and a speck of Phthalo Yellow-Green to the previous mixture. Use this tint to create the highlight in the central area of the lower foliage **Tree Details:** Mix Burnt Umber and the Light Blue-Gray mixture, and double load that on a liner with a mixture of the Pale Yellow and Pale Pink mixtures; then paint twigs and tree trunks in the shadowy areas of the foliage. Lightly blot the root of the wet trunks and twigs in the foliage and on the ground. Let dry.

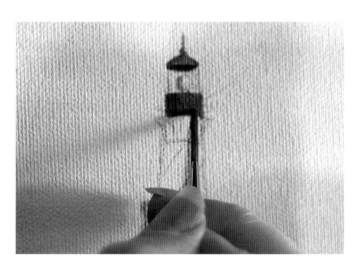

9 Paint the Lighthouse Dome

Transfer the lighthouse and boats with black transfer paper (page 7). Use the liner and no. 2 round to paint and blend the dome. Paint the underside of the dome with a brush mixture of Cadmium Red Medium and a speck of both Mars Black and Whiteblend. Let dry. Paint the left of the globe inside the dome with the Violet-Gray mixture and the right with Whiteblend; blend and dry. Paint the top of the dome Cadmium Red Medium using the no. 2 liner. Add a touch of Whiteblend to the right side and add a touch of the Violet Gray mixture to the dome top (left) and blend. Paint the mantle base using the same colors and technique. Let dry.

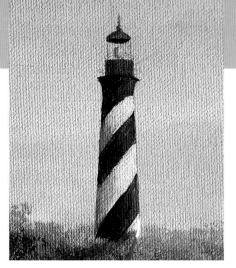

10 Paint the Lighthouse Base

Paint and blend one stripe at a time. Paint the stripes Mars Black with the angle brush. Highlight the right side with Mars Black mixed with a speck of Whiteblend. Add a speck of the Violet-Gray mixture to the Mars Black. Blend into the wet paint on the left edge to create reflected light. Let dry. Add a Whiteblend highlight on the extreme right and blend. Using the angle brush, paint the white stripes with Whiteblend on the right sides, adding the Violet-Gray mixture on the left; blend with a comb bush. Add equal parts of Whiteblend to a few dabs of the Pale Pink and Pale Yellow mixtures; randomly dab reflected lights in the wet Whiteblend on the right sides of the Whiteblend stripes. Let dry.

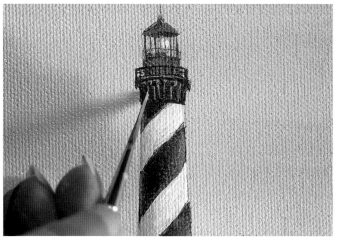

11 Create the Lighthouse Details

Add the moldings, antenna and handrails with the tip of the liner using watery Cadmium Red Medium. Make thin lines, putting little pressure on the brush. Shadow the handrail at the base of the mantle with a watery mixture of Cadmium Red Medium and a touch of Mars Black. Add the support braces underneath the walk platform with the liner using thinned Violet-Gray mixture. Curve these lines to the walk platform on both sides; make them straight in the center. Add a tiny dot at the end of each brace with the same color and brush.

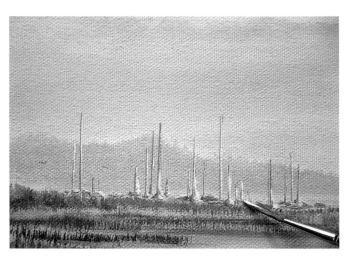

12 Add the Boats In the Marina

Suggest various-sized boats in the marina. Alternate double loading the Light Blue-Gray and Violet-Gray mixtures (shadows) with Whiteblend (highlights) on the liner. Put very little pressure on the brush for the masts. Keep them small and varied. If they wobble, stroke a clean angle brush along the edge to make them straight.

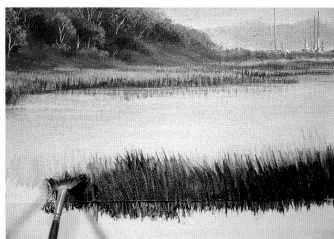

13 Paint the Foreground Grass

Apply the foreground marsh grass with a no. 2 fan and thinned paint, stroking from the root upward. Begin with the thinned Wheat mixture along the top of the grassy area. On the no. 2 fan, create a gradual transition from the Wheat mixture to Phthalo Yellow-Green to the Dark Brown-Green mixture. Make the grass strokes progressively darker and shorter as you progress to the bottom of the canvas.

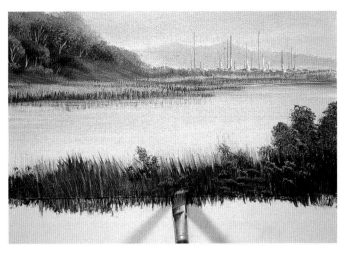

14 Add the Foreground Foliage Wildflowers

Stipple foliage and weeds in the corner and in small patches around in the marsh grass with the Dark Brown-Green mixture and the no. 8 bristle flat. Add Phthalo Yellow Green to the top of the uncleaned brush and stipple highlights on the top right sides of some foliage clusters. Stipple random patches of flower colors in the foreground grass using brush mixtures of light blue (Ultramarine Blue + Whiteblend) and pink (Cadmium Red Medium + Whiteblend).

15 Paint the Tall Grass

Pulling from the roots up, apply tall wispy blades of grass using watery grass colors from step 13 on the no. 2 liner. Make some grasses stand tall and straight and then paint some bending and leaning in the wind, crossing over each other.

16 Paint the Branches

Double load a liner with thin Burnt Umber and the Pale Yellow mixture. Apply gangly branches protruding from the large corner bush.

17 Add the Birds and Final Details

Apply suggestions of egrets wading in the marsh with tiny dabs of the double-loaded liner using Whiteblend and the gray colors in step 13. Rotate the brush to make the birds appear turned and leaning as well as standing straight. Using the same brush and colors, add gulls flying from the marina over the hill into the marsh. Sign your name and let dry. Spray the painting with aerosol acrylic painting varnish. Sit back and enjoy the view as you are approaching St. Augustine.

Maine Moorings

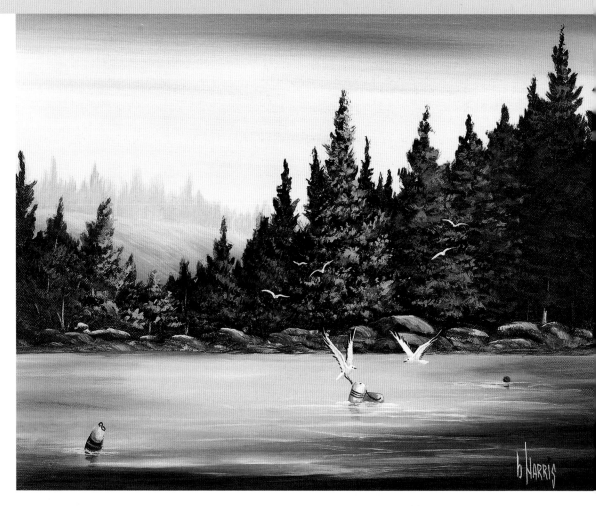

Maine Moorings
14" x 18"
(36cm x 46cm)

The Maine coastline is an unforgettable, awesome sight, with its rocky bluffs and beaches, ocean views and seemingly endless waterways. From old to new, from laborer to statesman, you will find every aspect of coastal life there.

While visiting Betty Allen, an artist friend who lives in Mt. Desert, Maine, I was inspired by the moorings as I learned how to identify each fisherman's buoy. Equally intriguing were stories of the seasoned lobstermen and the boats that so proliferate in the harbors.

The art lessons to be learned from visiting the Maine coastline are as varied as the scenery and culture. In order to share this experience with you, I composed a two-part lesson: *Maine Moorings* and *Lobster Joe*, based on actual photographs taken by Betty on our sightseeing adventure.

In this demonstration you will learn to compose a rocky shoreline with a backdrop of pine trees. The composition features a silent bay giving safe harbor to the moorings fastened to the lobstermen's traps, holding the bounty of their catch.

Materials

Acrylic Colors Burnt Umber, Cadmium Red Medium, Cerulean Blue, Hooker's Green, Payne's Gray, Phthalo Yellow Green, Titanium White, Ultramarine Blue, Yellow Ochre

Mediums Clearblend and Whiteblend

Brushes 2-inch (51mm) bristle flat, Nos. 4, 8 and 12 bristle flats, ¼-inch (6mm) sable/synthetic flat, No. 2 round, No. 2 liner, 1½-inch (38mm) hake or ¾-inch (19mm) mop, ½-inch (12mm) comb, ⅜-inch (10mm) sable/synthetic angle, No. 2 fan, Tapered painting knife

Pattern Enlarge the pattern (page 102) 156 percent.

Other 14" x 18" (36cm x 46cm) stretched canvas, Aerosol acrylic painting varnish, Black and white transfer paper, Paper towels, Stylus

Color Mixtures

Before you begin, prepare these color mixtures on your palette.

Off-White	Titanium White + a speck of Yellow Ochre
Light Yellow	50 parts Whiteblend + 1 part Cadmium Yellow Medium
Peach	Whiteblend + 2 parts Cadmium Red Medium + 1 part Yellow Ochre
Medium & Light Violet	1 part Cadmium Red Medium + 1 part Ultramarine Blue + various amounts of Whiteblend
Navy	20 parts Payne's Gray + 20 parts Ultramarine Blue + a touch of Whiteblend
Dark Blue-Green	2 parts Payne's Gray + 2 parts Ultramarine Blue + 1 part Hooker's Green
Medium Blue-Green	2 parts Dark Blue-Green + 1 part Whiteblend
Medium Teal Green	2 parts Hooker's Green + 1 part Ultramarine Blue + 1 part Cerulean Blue + Whiteblend
Medium Green	1 part Medium Teal Green + 1 part Phthalo Yellow Green + 1 part Whiteblend
Light Green	1 part Medium Green + 2 parts Phthalo Yellow Green + 3 parts Whiteblend
Light Gray-Green	Peach + a touch each of Dark Blue-Green and Whiteblend
Dark Brown	1 part Burnt Umber + 1 part Payne's Gray

1 Prepare Your Canvas and Lay In the Sky

Transfer the pattern to your canvas (page 7), omitting the birds and buoys. Apply a generous application of Whiteblend over the entire sky using your 2-inch (51mm) bristle flat. Wipe excess Whiteblend from the brush. While the canvas is still wet, begin laying in the sky with the same brush. Working from the bottom up, apply horizontal strokes of the Light Yellow mixture along the horizon. Lay in the Peach mixture through the center of the sky, adding streaks of the Navy and Dark Blue-Green mixtures at the top. Add Whiteblend to the Navy mixture to make a light blue-gray color; apply random streaks of that and the Medium Violet mixture throughout the peach areas using your no. 8 bristle flat.

2 Blend the Sky

Using strong then light pressure, blend the colors in the sky with your no. 12 bristle flat. Complete the final blending with your mop. Let dry.

3 Paint the Distant Trees

Moisten the area of the sky where the distant tree line will appear using a no. 12 bristle flat and Clearblend. Holding a no. 2 fan vertically and using only one corner of it, paint the distant tree line with downward strokes of the Light Gray-Green mixture. Apply random, vertical streaks in the lower portions of the trees with a brush-mixture of the Peach mixture and Whiteblend. Tap to soften some of the tree tops with a comb brush moistened with Clearblend. Wipe the brush clean, then tap to blend the streaks, creating the appearance of mist.

4 Define the Hillside

Cover the hillside generously with Whiteblend. Starting at the bottom and painting wet-into-wet, apply streaks of the Medium Blue-Green mixture sloping across the bottom two-thirds of the hillside; add more of the mixture in the bottom and less in the central area. Apply the Peach mixture sloping across the top third of the hill. Slightly blend the two colors using the side edge of your comb brush, again making sure your strokes coincide with the slope of the land.

5 Develop the Foreground Trees

With a no. 2 fan and the Dark Blue-Green mixture, create the foreground trees. Tidy their tops with the corner of a no. 4 bristle flat.

6 Shape the Foliage and Add Highlights

Stipple reflected light throughout the trees using the corner of a no. 2 fan and the Medium Teal Green mixture. Stipple highlights on the central portions and right sides of some trees with the Medium Green mixture. Add more Phthalo Yellow Green and Whiteblend to your uncleaned brush to create the Light Green mixture, then place additional highlights on a few foremost trees.

7 Paint the Shoreline Rocks

Scumble (make a series of of overlapping strokes in different direction) the Dark Brown mixture over the rocks on the shoreline using a no. 4 bristle flat. Define individual rock shapes using an angle brush double loaded with the Dark Brown mixture on the bottom and the Peach mixture on the top. Smudge the Dark Brown mixture to soften the transition between dark and light shapes. Apply a touch of reflected light on the left edge of some rocks using a liner and values of the Medium and Light Violet mixture. Soften the inside edge of the reflected light with a clean liner moistened with Clearblend. Let dry.

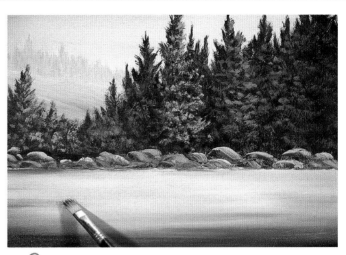

8 Lay In the Water

Using a 2-inch (51mm) bristle flat, paint the top two-thirds of the water with Whiteblend and the bottom third with the Navy mixture, overlapping and blending the colors where they join. Using the photo as a guide, apply streaks of the Peach, Medium and Light Violet, and Medium Blue-Green mixtures throughout the wet Whiteblend area with a no. 8 bristle flat. Blend, making horizontal strokes with a clean, dry no. 12 bristle flat.

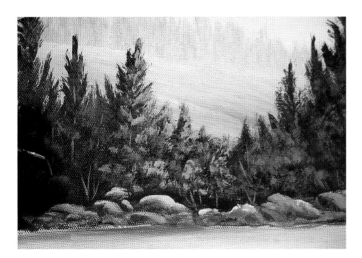

9 Add Twigs and Trunks to the Foliage

Using a liner double loaded with the Dark Brown and Peach mixtures, add trunks and twigs in a few areas of the foreground trees. Let this dry. Transfer the birds and buoys to the canvas.

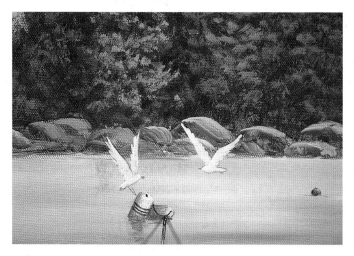

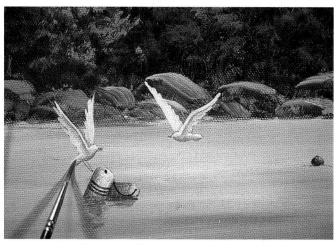

10 Paint the Buoys

Paint the buoys underneath the birds with your ¼-inch (6mm) flat and no. 2 round brushes, using the Violet-Gray mixture on the left and bottom and Whiteblend on the right. Place a dab of the Off-White mixture in the sunlit portions of the Whiteblend area and blend immediately using a clean no. 2 round. Paint the foremost buoy in the same manner, using deeper, more vibrant colors and adding both the Peach mixture and Whiteblend to the sunlit areas. Paint the distant buoy Cadmium Red Medium, creating shadows with the Navy mixture and highlights with the Peach mixture. Apply a Whiteblend basecoat for the two large gulls and let this dry.

11 Define the Sea Gulls

Paint the birds with Whiteblend using a no. 2 liner. Let dry. Load Clearblend on the no. 2 round and moisten the right wing. Apply a shadow on the wing next to the head and body with the Medium Violet mixture; blend that toward the wingtip into the Clearblend. Repeat for the other wing, placing the shadow along the inside edge. Blend toward the wing tip, following the direction the feathers grow. Apply Clearblend on the body, then add the shadow color along the stomach with a no. 2 liner. Blend the inside edge to create a curved shape. Let dry. Repeat for the second bird. Highlight the leading edge of the birds' wings, tops of their heads, backs and tails with the Off-White mixture on the no. 2 liner. Blend in toward the shadows with a no. 2 round loaded with Clearblend. Let it dry.

12 Add Further Details

Paint the birds' primary feathers, eyes, feet and legs using a liner and Payne's Gray. With the same brush, mix Cadmium Red Medium and Cadmium Yellow Medium with a touch of Titanium White and water, then paint the beaks.

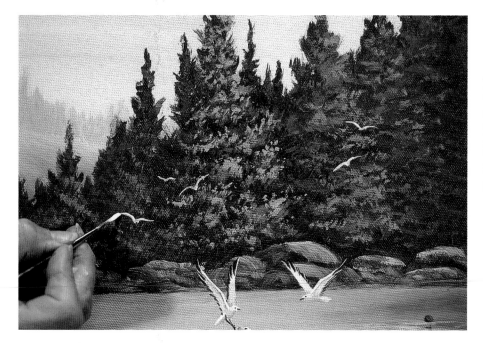

13 Paint the Sea Gulls In the Distance

Paint the soaring gulls using a liner double loaded with the Medium Violet mixture and Whiteblend. Hold the brush so that the Whiteblend is on the top and the Medium Violet mixture is on the bottom.

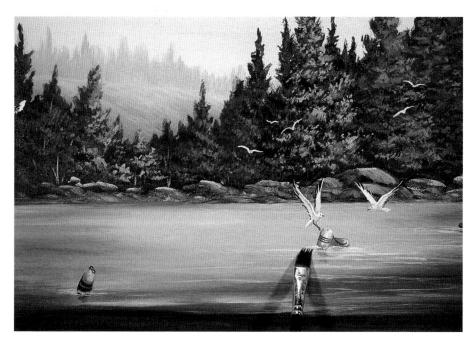

14 Add Reflections and Finishing Touches

Cover the water area with Clearblend using a 2-inch (51mm) bristle flat. Then, painting wet-into-wet, add the appropriate buoy colors beneath each buoy using a liner and a ¼-inch (6mm) flat. Smudge, stroking horizontally across the reflected colors, leaving only a faint suggestion of the object being reflected. Let this dry, then moisten the water with Clearblend once again. Use a liner and Whiteblend to create water lines, slightly blending the edges into the Clearblend. Repeat until all water lines are completed. Sign your painting and let it dry. Erase or wipe away any remaining graphite marks and spray with aerosol acrylic painting varnish. Anchor your *Maine Moorings* masterpiece in a frame and display it in a special place!

Lobster Joe

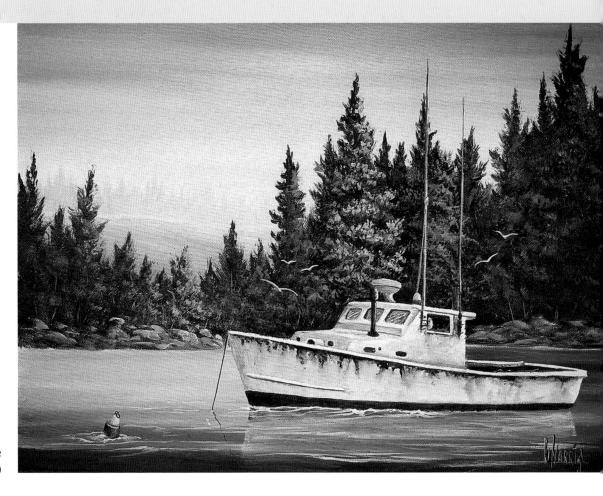

Lobster Joe
14" x 18" (36cm x 46cm)

Most lobster boats are rustic in appearance and seem makeshift and worn, but looks can be deceiving; these boats are the lifeline to Maine's lobster industry, which is big business. The basics of lobstering have remained the same over the years. I am told that it is a hard, rugged, yet wondrously exhilarating life, requiring a lobsterman to be "married to the sea." It is easy to see why lobster boats are the icons of the Maine coast.

Lobster Joe is a simplification of a boat that has long since outlived its usefulness as a harvester and is now at the bottom of the sea, creating a "reef" habitat for sea life. I derived this composition from an inspiring photograph supplied by my friend Betty Allen. Thanks, Betty.

In this lesson you will use the background from *Maine Moorings* (page 44), while learning many more techniques. You will create form and volume by blending wet colors into wet colors, as well as layering wet colors over dry. You will learn to duplicate the look of years of wear with dribbles and runs of paint, as well as shimmers of light bouncing from a windshield. No need to worry about duplicating every detail exactly, as the old boats have been altered many times over the years with makeshift parts, making each unique. Feel free to add your own special touches.

Materials

Acrylic Colors Burnt Sienna, Burnt Umber, Cadmium Red Medium, Cerulean Blue, Hooker's Green, Payne's Gray, Titanium White, Ultramarine Blue, Yellow Ochre

Mediums Clearblend and Whiteblend

Brushes 2-inch (51mm) bristle flat, ¼-inch (6mm) sable/synthetic flat, No. 2 liner, 1½-inch (38mm) hake or ¾-inch (19mm) mop, ½-inch (12mm) comb, ⅜-inch (10mm) sable/synthetic angle, Tapered painting knife

Pattern Enlarge the pattern (page 103) 182 percent.

Other 14" x 18" (36cm x 46cm) stretched canvas, Aerosol acrylic painting varnish, Adhesive paper, Black and white graphite paper, Paper towels, Stylus

Color Mixtures

Before you begin, prepare these color mixtures on your palette. When you are painting the sky, background, foliage and water, use the color mixtures on page 45.

Off-White	Titanium White + a speck of Yellow Ochre
Medium & Light Violet	1 part Cadmium Red Medium + 1 part Ultramarine Blue + various amounts of Whiteblend
Light Teal	Whiteblend + a touch of Cerulean Blue
Dark Blue-Green	2 parts Payne's Gray + 2 parts Ultramarine Blue + 1 part Hooker's Green
Medium Blue-Green	2 parts Dark Blue-Green + 1 part Whiteblend
Rusty Red	Brush mix Burnt Sienna + Cadmium Red Medium
Dark Brown	1 part Burnt Umber + 1 part Payne's Gray

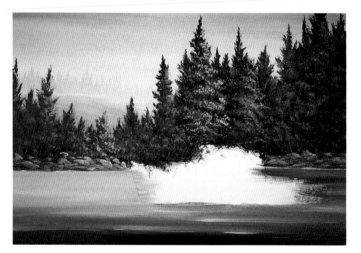

1 Prepare Your Canvas

Omitting the birds and buoys, transfer the patterns for *Maine Moorings* and the lobster boat to your canvas (page 7). Using a liner and Payne's Gray, paint the portholes and underline the moldings. Then make a design protector (page 7) and place it over the boat.

Refer back to project six (page 44) for directions for painting the sky, background foliage and water.

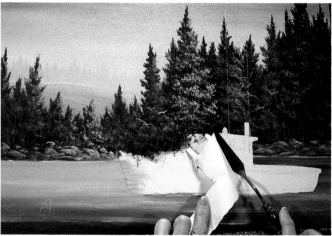

2 Remove the Design Protector

Using your painting knife to help loosen stubborn areas, remove the design protector.

3 Draw the Antennas

Using your liner double loaded with the Medium Violet mixture on the left and the Off-White mixture on the right, draw the antennas. Correct crooked or uneven thicknesses in the antennas with a clean, moist angle brush. Paint the brackets holding the antennas using a liner double loaded with Payne's Gray and the Off-White mixture.

4 Paint the Portholes, Windows and Cabin Shadows

Paint the portholes using a liner and Payne's Gray. Add shadows inside the cabin using an angle brush and the Dark Brown mixture. Then with an angle brush, apply the Dark Blue-Green mixture inside the front windows. Let dry.

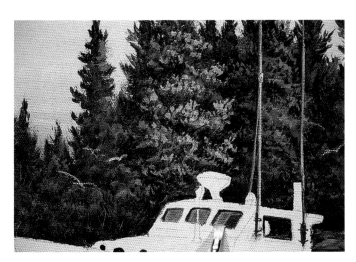

5 Glaze the Window Panes

With an angle brush, mix a light, translucent blue-green glaze using Clearblend with just a touch of both White-blend and the Medium Blue-Green mixture. Apply this glaze over the glass on the front windows using the same brush. Touch up the gasket bordering the windows using your liner and the Dark Blue-Green mixture.

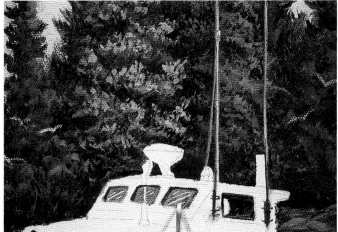

6 Add Reflected Light on the Windows

Add parallel, diagonal streaks of reflected light across the window panes using a liner and Whiteblend.

7 *Place the Cabin Shadows and Highlights*

Working one section at a time and painting wet-into-wet, apply the cabin shadows and highlights. Moisten each section with Clearblend using a no. 8 flat. While wet, lay in shadows using an angle brush and the Medium Violet mixture. Blend the shadows, pulling the paint toward lighter areas with a comb brush. Add dashes of the Off-White mixture in the lighter areas using a ¼-inch (6mm) flat. Blend as before. Paint the radar console on top of the hull in the same manner.

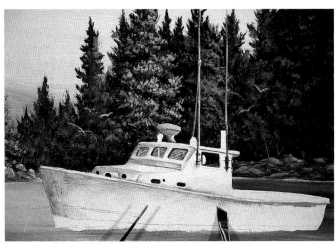

8 *Apply the Hull Shadows and Highlights*

Using the same technique and colors from step 7, add the shadows and highlights on the hull. Dry thoroughly.

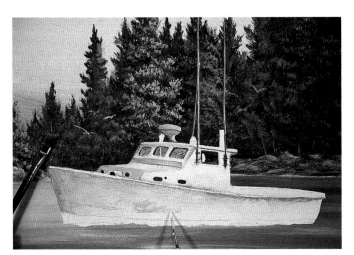

9 *Paint Reflected Light on the Cabin and Hull*

Working one section of the cabin and hull at a time, reapply Clearblend using a no. 8 flat. While wet, apply the Light Teal mixture with a liner to suggest reflected light. Blend toward the light using a comb brush moistened with Clearblend.

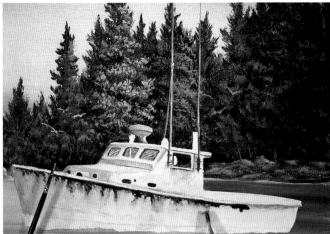

10 *Add Rust and Mud to the Boat*

Still working one section at a time, randomly dab clean water on small sections of the hull and cabin. Using your liner, apply dabs of creamy Burnt Sienna underneath the rails and in the wet areas. Drip more water on the Burnt Sienna dabs, making them run, drizzle and disperse randomly. Remove excess water with a clean, moist brush or sponge. Repeat for all sections. Let this dry.

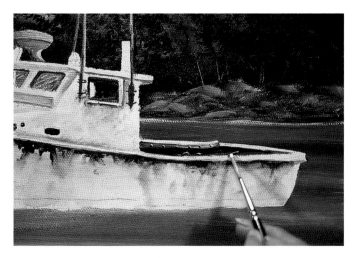

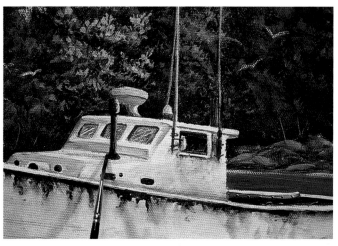

11 Paint the Hull Interior and Moldings

Unevenly apply the Dark Brown mixture inside the hull using an angle brush. Paint the inside edge of the moulding with a liner and a tan brush-mixture of the Dark Brown mixture and Whiteblend. Paint all other boat moldings with Whiteblend, and add shadows with watery Medium Violet mixture, alternated with watery Dark Brown mixture. Add bolts and cleats on the rails using a liner double loaded with Payne's Gray on one side and the Off-White mixture on the other.

12 Define the Exhaust Pipe and Other Details

Use a liner and Burnt Sienna to paint the exhaust pipe. Shadow it with Burnt Umber and add highlights with the Off-White mixture, then blend. For the details on top of the boat, use a mixture of Burnt Sienna and Cadmium Red Medium. To shape the top of the piece attached to the antenna line, use the Light and Medium Violet mixtures as well as the Off-White mixture. Add the rear-view mirror using a liner and the same colors used for the antenna line.

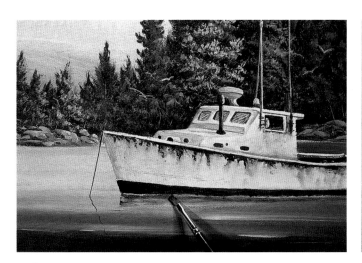

13 Fill In the Bottom of the Boat

Using an angle brush, paint the bottom of the boat with the Rusty Red mixture. Shadow the color with Burnt Umber. Add Clearblend to the Rusty Red mixture. Streak a translucent reflection of the boat's bottom across the water, directly beneath the boat.

14 Finish Shaping the Foreground Buoy

Using a liner and ¼-inch (6mm) flat, paint the top of the buoy with the Light Violet and Off-White mixtures. Paint the bottom and the stripe using the Rusty Red mixture shadowed with Burnt Umber. Let this dry, then add the hook and eye on top of the buoy using a liner and a thinned mixture of Payne's Gray.

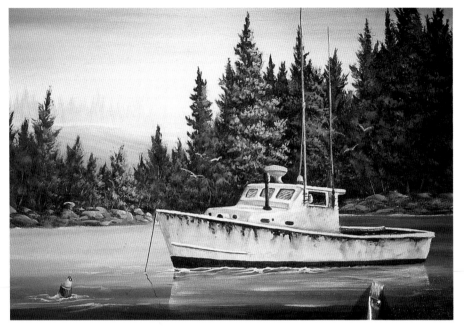

15 Add the Water Details

Using a 2-inch (51mm) bristle flat, moisten the foreground water with Clearblend. While still wet, apply an uneven, translucent reflection directly beneath the boat's bottom reflection using an angle brush lightly loaded with Clearblend and a touch of Whiteblend. Still painting wet-into-wet, add dabs of watery Burnt Sienna to the reflection. Blend slightly with your hake or mop and let this dry. Now, remoisten the entire water area using your 2-inch (51mm) bristle flat loaded with clean water, then Clearblend. Apply the water ripples and lines using a liner and Whiteblend. Blend the edges and bottoms of the lines and ripples with a comb brush moistened with Clearblend.

16 Paint the Sea Gulls in Flight

Paint the soaring gulls using a liner double loaded with the Medium Violet mixture and Whiteblend. Sign your painting and let it dry. Remove all excess graphite or tracing lines, then spray it with aerosol acrylic painting varnish. Now, how about a nice lobster dinner? May all your catches be big ones!

Last Stop

Last Stop
16" x 20" (41cm x 51cm)

Old buildings from our past make great subjects for our canvasses. This little depot, which quite by accident gave the town of Davis, Oklahoma, its name, is much like those that dot the country in small railroad towns.

As legend has it, when the Santa Fe Railroad came through and built this depot in the town of Chigley, Oklahoma, the two men hired to paint the name on the depot could neither read nor write. They copied the name *Davis* from a mercantile store across the street, thinking it was the name of the town. Before the sign could be changed,

another town registered the name Chigley with the U.S. postal service, and so the name Davis remained.

The Santa Fe still comes through Davis, and the town has flourished to become a bustling city. This small building has seen its last stop as a train depot. However, unlike many that were torn down to make way for bigger and newer buildings, this depot was transformed into a historical society museum with displays and artifacts dating back to 1850. It's certainly a fun place to visit. Maybe some day you'll stop by with your camera for a visit as well!

Materials

Acrylic Colors Burnt Sienna, Burnt Umber, Cadmium Red Light, Cadmium Yellow Medium, Dioxazine Purple, Hooker's Green, Mars Black, Phthalo Yellow Green, Ultramarine Blue

Mediums Clearblend and Whiteblend

Brushes Nos. 4, 8 and 12 bristle flats, ¼-inch (6mm) sable/synthetic flat, No. 2 liner, 1½-inch (38mm) hake or ¾-inch (19mm) mop, ½-inch (12mm) comb, ⅜-inch (10mm) sable/synthetic angle, No. 2 fan, Tapered painting knife, Natural sea sponge

Pattern Enlarge the pattern (page 104) 145 percent.

Other 16" x 20" (41cm x 51cm) stretched canvas and mat template, Adhesive paper, Black transfer paper, Paper towels, Shipping or masking tape, Stylus, Ultrafine-point waterproof permanent marker or technical pen (black ink)

Color Mixtures

Before you begin, prepare these color mixtures on your palette.

Off-White	Whiteblend + a touch of Cadmium Yellow Medium
Pale Yellow	10 parts Whiteblend + 1 part Cadmium Yellow Medium
Pale Peach	Whiteblend + a touch each of Cadmium Red Light and Cadmium Yellow Medium
Lime Green	1 part Whiteblend + 1 part Phthalo Yellow Green + 1 part Cadmium Yellow Medium
Dark Green	1 part Hooker's Green + 1 part Burnt Umber + 1 part Ultramarine Blue + 1 part Burnt Sienna
Light Blue	10 parts Whiteblend + 1 part Ultramarine Blue
Light Violet-Gray	10 parts Whiteblend + 3 parts Ultramarine Blue + 1 part Cadmium Red Light
Grape	1 part Dioxazine Purple + 1 part Ultramarine Blue + 1 part Burnt Umber
Deep Grape	1 part Dioxazine Purple + 1 part Mars Black

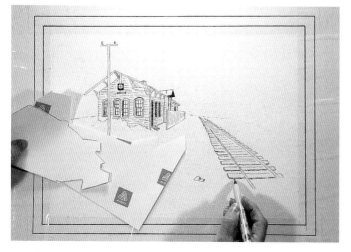

1 Prepare Your Canvas

Follow the instructions for French Matting on page 7, using two templates to create the appearance of a double mat. Allow the Clearblend to dry, then transfer the design (page 7). Next, paint the eaves and dark shadows inside the windows and doors on the right side of the train station with your ¼-inch (6mm) flat and the Deep Grape mixture. Ink the lines on the building, electrical pole, train tracks and selected rocks using your technical pen or marker. Let dry. Make a design protector (page 7) and place it over the train station.

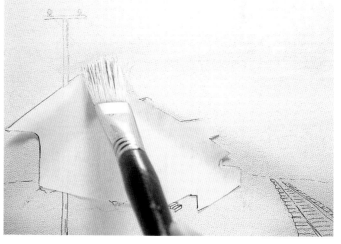

2 Lay In the Sky

Cover the sky with Whiteblend using your no. 12 bristle flat. While it's still wet, apply the Pale Peach mixture in the lower sky and a hint of the Light Blue mixture in the central area using your no. 8 bristle flat. Blend with a clean no. 2 fan, then scumble the outer edges until they disperse, then complete the blending with your hake or mop.

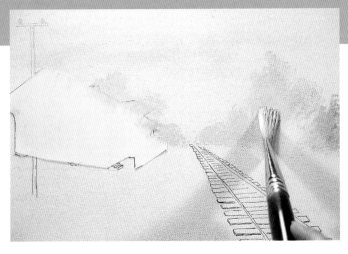

3 Establish the Distant and Middle Foliage

Using the corner of a no. 2 fan and alternating between the Light Blue and Light Violet-Gray mixtures, paint the mist around the outer edges of the tree shapes. Tap and soften the outside edges using a no. 8 bristle flat moistened with Clearblend, creating the distant tree shapes. Smudge some color over the center of the distant ground area, leaving no hard edges. Add a touch of the Dark Green mixture to the Light Blue and Light Violet-Gray mixtures, and apply various values of this mixture to the middle foliage shapes. Tap to soften select edges as before.

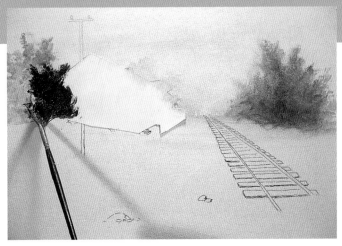

4 Develop the Foreground Trees

Using the corner of a no. 2 fan and alternating between the Dark Green mixture, Burnt Umber and Burnt Sienna, stipple the foreground trees to the left and behind the train station. Tap to soften some tree tops using your no. 8 bristle flat moistened with Clearblend. Anchor the trees and create the contour of the land using the same brush. If necessary, add a touch of the tree colors to your brush to establish the shadows below the trees. While it's wet, add a few mounds of earth using the Pale Peach mixture.

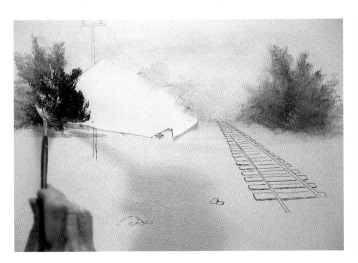

5 Add Highlights to the Trees

Stipple highlights on the left side of the trees behind the train station using a no. 4 flat double loaded with Clearblend on one side and a mixture of Phthalo Yellow Green and the Light Blue mixture on the other. Highlight the middle and foreground trees with a no. 2 fan double loaded with Phthalo Yellow Green and Clearblend on the other. Add the Pale Yellow mixture to the Phthalo Yellow Green for the brightest highlights. Blot along the bottom to create a gradual transition between highlights and shadows.

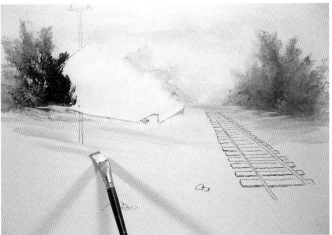

6 Lay In the Ground

Using a 2-inch (51mm) flat, moisten the ground area with water and Clearblend. While still wet, lay thin washes using your comb brush. Alternate between several brush-mixed colors, including Burnt Umber and Whiteblend, Burnt Sienna and Whiteblend, and the Peach and Off-White mixtures. Place the most vivid colors closest to the train station and the lightest colors nearest the edges of the tape. Blend slightly with your no. 12 bristle flat. Use a clean no. 2 fan to scumble the colors along the bottom and the edges. Let this dry.

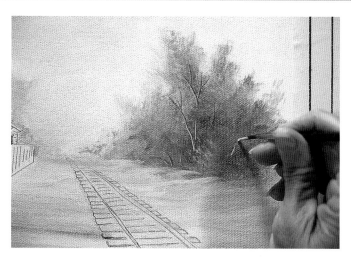

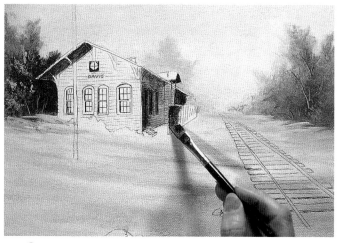

7 Draw the Tree Trunks and Twigs

Draw tree trunks and twigs in the middle and foreground foliage using your liner double loaded with the Grape and Peach mixtures.

8 Add the Train Station Shadows

Paint the eaves on the station using a ¼-inch (6mm) flat and the Deep Grape mixture. Once this dries, apply and blend one section of the remaining shadows at a time, creating transitions between light and dark and giving form to the building and fence. Using your angle brush, mix a translucent glaze of Clearblend and the Grape mixture. Apply this glaze over the section to the right of the station. Strengthen the darkest areas of the shadows with the Deep Grape mixture. Blend with a comb brush moistened with Clearblend. Repeat for each section, then let your canvas dry.

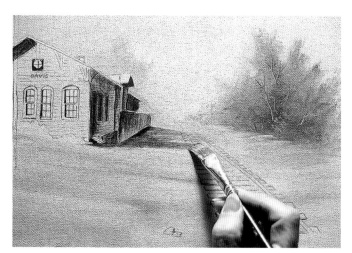

9 Apply the Ground Shadows

Moisten the ground that is to remain lightly shadowed using your no. 8 bristle flat and Clearblend. With the same brush, apply shadows horizontally across the ground with the Grape and Deep Grape mixtures, overlapping into the wet Clearblend.

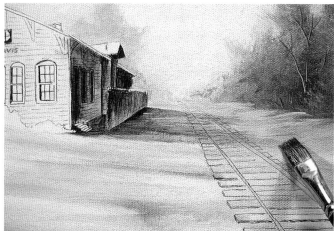

10 Blend the Ground Shadows

Using your comb brush moistened with Clearblend, blend the wet shadows horizontally across the tracks, making them disappear before reaching the middle foliage on the right.

11 Glaze the Building and Paint the Eave and Window Shadows

With your angle brush, apply a translucent glaze of Clear-blend and the Off-White mixture over the end of the train station. Let this dry, then apply a pale, translucent mixture of the Grape mixture and Clearblend below the eave, suggesting the cast shadow. Randomly blot to subdue and create irregularities in the shadow. Still using your angle brush, apply this same Grape glaze to the top half of the windows and paint the bottom half of the windows using the Light Blue mixture. Blend with your comb brush; let dry.

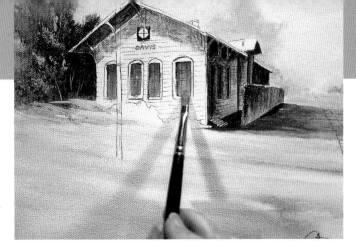

12 Define the Roof, Chimney and Emblem

Mix and apply the roof and chimney colors using a liner. Mix a terra cotta color from Burnt Sienna and Whiteblend for the darker portions. Mix a coral color from Whiteblend and Cadmium Red Light for the lighter areas and the trim. Print the name of your choice on the building and create the border around the emblem using your liner and a watery mixture of Mars Black. (You also can use a technical pen or marker). Use thinned Cadmium Red Light for the cross.

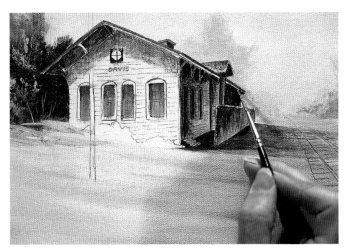

13 Paint the Moldings and Window Detail

Paint the moldings using your liner and a mixture of Whiteblend and the Off-White mixture. Remove crooked or irregularly shaped moldings with a clean, moist angle brush and let your canvas dry. Using a no. 2 liner, add shadows with an inklike mixture of Clearblend and the Grape mixture, using the Deep Grape mixture for the darkest areas.

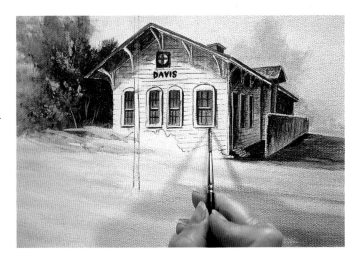

14 Refine the Tracks

Still using the liner, apply a thin mixture of Light Violet-Gray on the distant portions of the tracks, suggesting cast shadows. Darken this with the Grape mixture and lay in the shadows in the foremost areas. Highlight selected areas on some of the boards under the tracks using the Off-White and/or Pale Peach mixtures. Make the tracks progressively closer together and narrower as they move into the distance, and wider and farther apart as they move into the foreground. This perspective technique will create the illusion of depth.

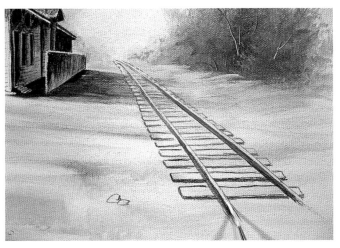

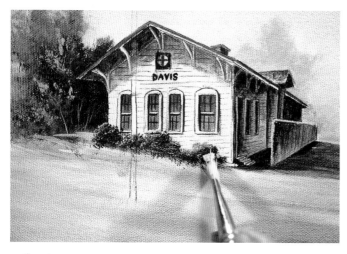

15 Apply the Shrubs

Using your no. 4 bristle flat and alternating between the Dark Green mixture, Burnt Sienna and Burnt Umber, apply the shrubs adjacent to the building. Add Phthalo Yellow Green to the top of the uncleaned brush and tap highlights on the top-left sides of select clusters. Continue developing highlights, adding the Pale Yellow mixture to the uncleaned brush. Anchor the shrubs, adding shadows with your comb brush and a mixture of Clearblend and the Grape mixture. Make your brushstrokes according to the slope of the land.

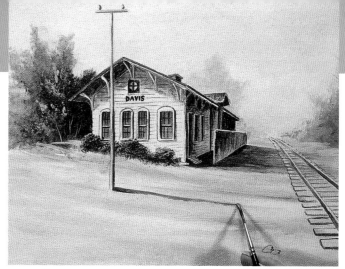

16 Define the Telephone Pole

Apply the pole and insulators using your liner double loaded with the Grape mixture on the right side and the Off-White mixture on the left. Apply shadows with a no. 2 liner and a translucent mixture of Clearblend and the Grape mixture. Again, make sure your brushstrokes correspond with the slope of the land. Draw the thin wires using a liner and a watery mixture of Grape. Correct irregularities in the wires with a moist angle brush.

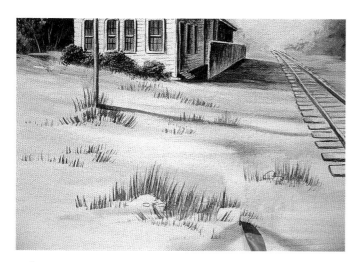

17 Add the Grass

Create clusters of grass using your comb brush and thinned Dark Green mixture, Burnt Umber and Burnt Sienna. Blot to soften the root areas of the grass clumps. Add the taller grasses using the same colors and a liner. Add a few ground shadows cast from the grass clusters and shrubs with your liner and a watery mixture of the Grape mixture and Clearblend.

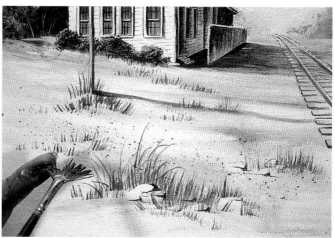

18 Finish the Ground Details

Speckle your painting using a no. 2 fan and thinned Off-White mixture. Dry and repeat with the Deep Grape mixture. Use a moist sponge to remove excess or stray splatters. Dab a few rocks in and around the foreground grass with a marbleized mixture of Whiteblend and the Off-White mixture. Add shadows beneath and to the right of some rocks and large splatters using your liner and a thin, translucent mixture of Clearblend and the Grape mixture. Sign your painting; let dry. Remove the tape, soak up any seepage with a moist sponge, and spray your canvas with aerosol acrylic painting varnish. Don't let this be your "last stop"; paint another for someone special using the appropriate town name!

Garden Window

A window box with flowers overlooking a flower garden makes a perfect subject for a multitude of painting techniques and ideas.

In this painting you will not only learn to create the illusion of three dimensions, but of three planes, too: outside the window, the window itself, and inside the window. With the assistance of glazing, you will also learn to create the illusion of glass and the impression of peering through it.

With the help of acrylic modeling paste, you will learn that creating the realistic appearance of weathered plaster, stucco and old brick is a snap—and lots of fun. Modeling paste can be added to your colors, or it can be used to sculpt the surface, to be painted over when dry. This is how we will use the medium in this demonstration.

After you have done this project, think of how you can use these techniques to create new paintings or enhance objects in your paintings. The opportunities are endless. Visualize rocks, trees and clouds with texture added. Think of a vase created with glazes painted over flower stems—the ideas are limitless.

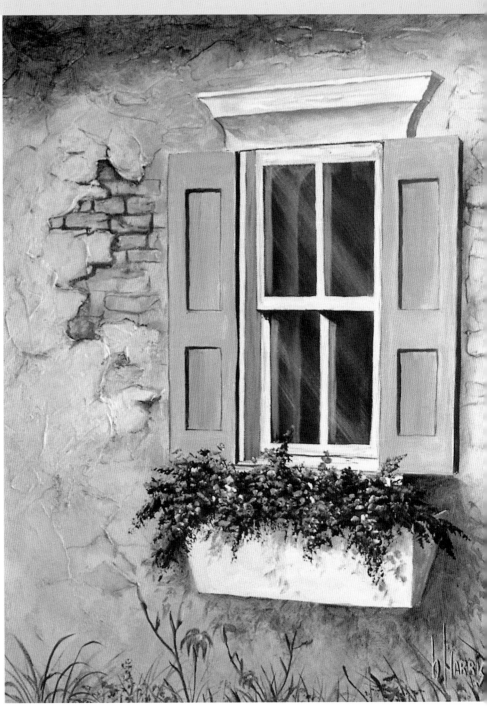

Garden Window
20" x 16" (51cm x 41cm)

Materials

Acrylic Colors Burnt Umber, Cadmium Red Light, Cadmium Yellow Medium, Cerulean Blue, Dioxazine Purple, Hooker's Green, Payne's Gray, Phthalo Crimson, Phthalo Yellow Green, Raw Sienna, Titanium White, Ultramarine Blue

Mediums Clearblend, Slowblend and Whiteblend

Brushes 2-inch (51mm) bristle flat, No. 8 bristle flat, ¼-inch (6mm) sable/synthetic flat, No. 2 liner, 1½-inch (38mm) hake or ¾-inch (19mm) mop, ⅜-inch sable/synthetic angle, No. 2 fan, Tapered painting knife, Natural sea sponge

Pattern Enlarge the pattern (page 105) 185 percent.

Other 20" x 16" (51cm x 41cm) stretched canvas, Acrylic modeling paste, Aerosol acrylic painting varnish, Black transfer paper, Paper towels, Small containers for glazes, Stylus, Ultrafine-point waterproof permanent marker or technical pen (black ink)

Color Mixtures

Before you begin, prepare these color mixtures on your palette. Mix the glazes in small disposable containers.

Cream	Titanium White + a touch of Raw Sienna
Light Blue	2 parts Whiteblend + 1 part Cerulean Blue + 1 part Payne's Gray
Violet-Gray	1 part Dioxazine Purple + 1 part Payne's Gray + 4 parts Whiteblend
Bright Yellow	1 part Cadmium Yellow Medium + 1 part Whiteblend
Marbleized Peach	2 parts Cadmium Red Light + 1 part Whiteblend
Dark Green	1 part Payne's Gray + 1 part Cerulean Blue + 1 part Hooker's Green + 1 part Dioxazine Purple
Medium Green	2 parts Phthalo Yellow Green + 1 part Dark Green
Dark Brown	1 part Burnt Umber + 1 part Payne's Gray + 2 parts Dioxazine Purple + Clearblend
Raw Sienna Glaze	3 parts Raw Sienna + 1 part Burnt Umber + 30 parts Clearblend
Teal Glaze	4 parts Clearblend + 1 part Cerulean Blue + 2 parts Whiteblend

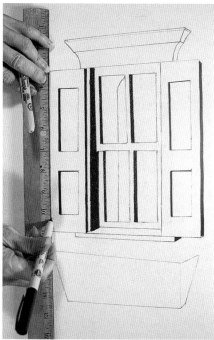

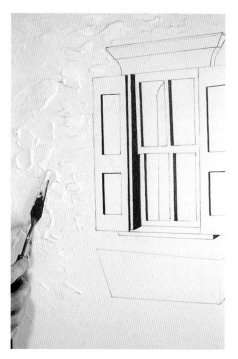

2 Add Sculptured Texture

Sculpt the raised bricks on the wall with the back side of your painting knife and a moderate amount of modeling paste. Create adobelike texture with thicker gobs of modeling paste, moving it around erratically with your knife. Leave the adobe texture raised higher than the brick shapes so the mortar will look as though it's breaking and falling away. Scrape harder and apply less texture below the window. Add slight, horizontal woodgrain streaks on the flower box and trim using the side edge of your knife and a small amount of modeling paste. Allow this to dry thoroughly, preferably overnight.

1 Prepare Your Canvas

Transfer the design to your canvas (page 7). Mark the lines around the shutters, window and flower box with your permanent marker. Use your liner and ¼-inch (6mm) flat with Payne's Gray to mark the wider lines.

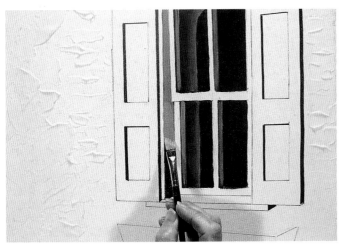

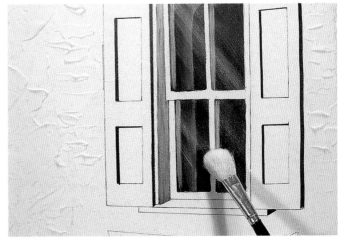

3 Paint Shadows Inside the Window

Paint the arched opening inside the window using your angle brush and the Dark Brown mixture. Add Clearblend to the uncleaned brush for the lighter edge of the arch. Paint the inside edge of the molding that holds the window pane using your liner and the Violet-Gray mixture. Mix and apply the Violet-Gray mixture and Payne's Gray to the outside moulding using your angle brush. Dry thoroughly.

4 Create the Glare on the Glass

Moisten the window panes using Clearblend and a no. 8 flat. Streak the Teal glaze diagonally across the window panes to suggest the glare on the glass. Lightly soften the streaks with your hake or mop, stroking your brush in the direction of the streaks. Let this dry.

5 Define the Cracks and Mortar Joints

Paint the shadows cast from the mortar joints and cracks in the adobe wall using your liner and a thin mixture of Dark Brown. Soften the shadows with your hake or mop as needed. Allow your canvas to dry.

6 Glaze the Adobe Wall

Lay the Raw Sienna glaze over the adobe wall using your no. 8 bristle flat, followed by your 2-inch (51mm) bristle flat. Add more Clearblend to the mixture for lighter areas and more Raw Sienna for darker areas.

7 Add Plaster Highlights

Highlight a few raised areas of plaster around the mortar cracks using your angle brush and the Cream mixture. Blend the inside edge of the highlights with your no. 8 bristle flat moistened with Clearblend. Highlight a few bricks in the same manner. Let this dry.

8 Define the Window Moldings

Paint the sunlit side of the window's frame moldings using a no. 2 liner; alternate using the Cream mixture and Whiteblend, making it mottled, thick and thin. Apply faint streaks on the molding with the Violet-Gray mixture and the no. 2 liner to create the wood-grain. Let dry. Paint the molding in the shadow with the Violet-Gray mixture and the no. 2 liner. Leave traces of black showing between the fronts and sides of the frame moldings. Use the same brush and colors to paint the window sill and the exterior moldings. Add a thin shadow separating the crown molding from the window using the no. 2 liner and a thin mixture of Payne's Gray and Clearblend. Use the same mixture to apply the shadows angling across the top of the bottom vertical molding. Soften the bottom edges of the shadow with the comb brush.

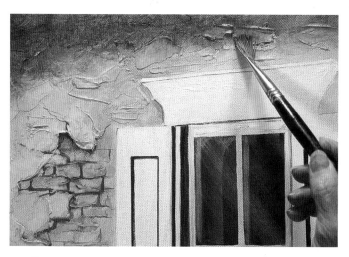

9 Paint Shadows Cast by the Roof

Moisten the area above the window using your no. 8 bristle flat loaded with Clearblend. While it's still wet, lay in the shadow (cast by the unseen roof) along the top of the canvas using your angle brush and the Dark Brown mixture. Soften the edges with your hake or mop. Dry and touch up if needed.

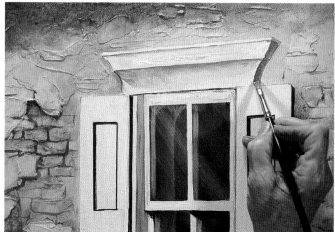

10 Paint the Crown Molding

As you're working in this step, paint wet-into-wet, leaving the paint modeled and streaked to resemble aged wood. First paint the top crown molding with an angle brush, alternating between Whiteblend and the Cream mixture. Add streaks of the Violet-Gray mixture randomly through the wet paint; blend them slightly with the comb brush. Add a shadow with the Violet-Gray mixture below the top of the crown molding using a no. 2 liner; soften the lines with a comb brush. Paint the bottom of the crown molding using Whiteblend and the Cream mixture loaded on the angle. Add shadows with the Violet-Gray mixture and the ¼-inch (6mm) flat. Blend with the comb brush, leaving a deeper shadow along the top of the board. Paint the shadow on the right with the Violet-Gray mixture and the ¼-inch (6mm) flat.

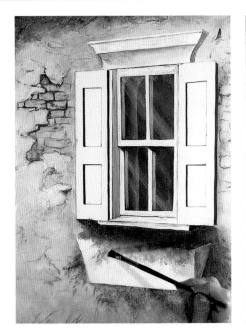

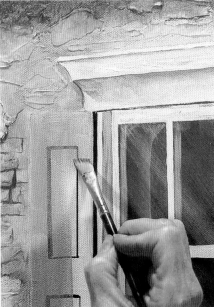

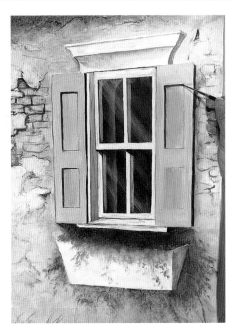

11 Add Shadows Cast by Foliage and Flowers

Paint the flower box with an angle brush, alternating between White-blend and the Cream mixture. Moisten the areas around the flower box with Clearblend, then dabble foliage shadows using your no. 8 bristle flat and the Dark Brown mixture; blend with your hake or mop to soften. Let dry. Apply the shadows along the bottom of the wall (cast by flowers not yet painted) using a liner and watery Dark Brown mixture. Let dry. Using the same brush, moisten the flower box with Clearblend and dabble leaf-shaped shadows on the flower box itself with a mixture of the Violet-Gray mixture and Clearblend. Soften as before.

12 Paint the Shutters

Using your angle brush, paint the shutters with a thin application of the Light Blue mixture. Slightly darken this mixture, adding a touch more Cerulean Blue and Payne's Gray, then paint the recessed boards on the shutters. Let dry.

13 Add the Shutter Details

With your liner, brush-mix a soupy deep blue-violet color using Dioxazine Purple, Cerulean Blue, Payne's Gray, Whiteblend and water. Repaint the shadows on the sides and around the recessed panels on the shutters with this mixture and let your canvas dry.

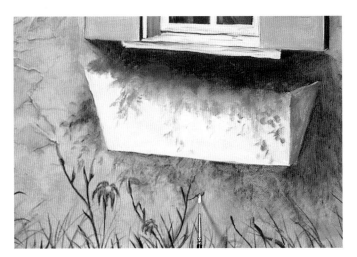

14 Paint the Flower Stems and Petals

Paint the flower stems and leaves using a liner and soupy Dark Green mixture. Highlight select areas with the Medium Green mixture and Phthalo Yellow Green. Still using your liner, paint the petals with a brush mixture of Cadmium Red Light and a touch of Whiteblend, and fill in the centers with the Bright Yellow mixture. Blend slightly. Touch up the tips with a no. 2 liner and watery Cadmium Red Light.

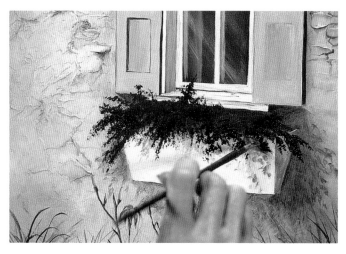

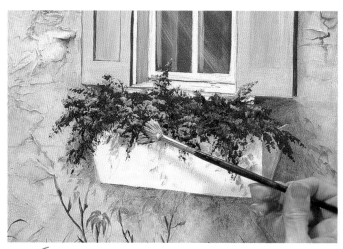

15 Shape the Ferns

Using the corner of a no. 2 fan, stipple ferns in the flower box with the Dark Green mixture. Be sure to vary the position of the ferns, making some fronds hang over the flower box and others stand up in front of the shutters and window sill.

16 Place Highlights on the Ferns

Highlight the ferns using the corner of a no. 2 fan and the Medium Green mixture, followed by Phthalo Yellow Green. Don't paint solidly; allow some of the dark green base to show through. Let dry.

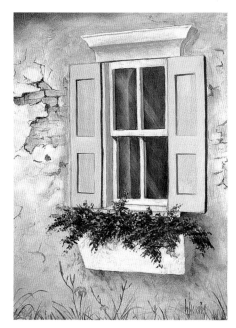

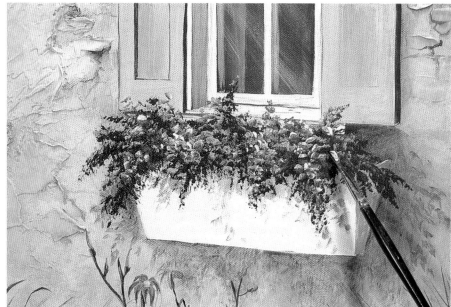

17 Further Develop the Flowers

Dab impressionistic clusters of flowers in the window box using the corner of your sable/synthetic flat and the Marbleized Peach mixture. Let dry. Add more Whiteblend to the mix to create the almost white highlights.

18 Add More Blossoms

Using the same technique from the previous step, create additional flowers using Cerulean Blue, Phthalo Crimson, Ultramarine Blue, Dioxazine Purple and any other colors you choose. Dry between each color application. Using a small piece of a moist sponge, lightly stipple some of the flower colors along the bottom of the canvas to indicate a few coordinating blooms on the ground. Sign your painting and let it dry. Spray with aerosol acrylic painting varnish, then look out your garden window to see what's blooming!

Sky High

Nothing is more captivating than a warm, breezy day at the beach. Since the beginning of time, the ocean has inspired countless artists. The seamless union of water and sky is simply breathtaking, making it the perfect subject for a painting.

In this composition, you will spend a great deal of time working on the sky, practicing both the wet-on-wet and wet-on-dry techniques. You'll create large masses of billowing foreground clouds along with smaller distant formations, giving your painting a sense of depth. You'll also create the illusion of breaking waves and receding tide waters as they roll away from the sandy shoreline. There's much to do, so let's get started. The gulls eagerly await your arrival!

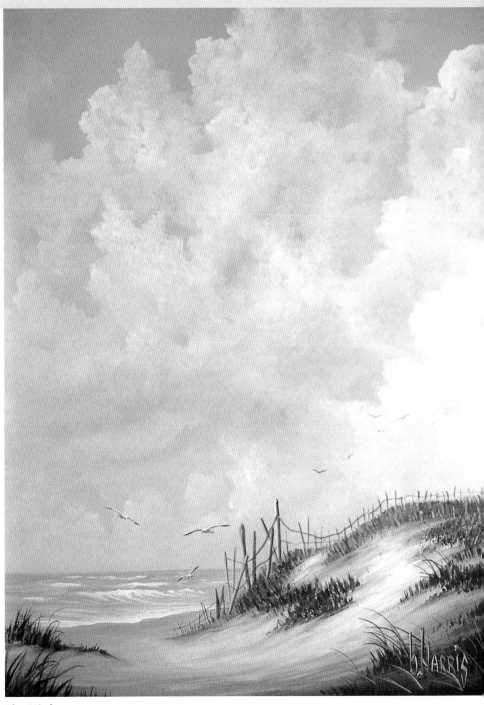

Sky High
20" x 16" (51cm x 41cm)

Materials

Acrylic Colors Burnt Umber, Cadmium Red Light, Cadmium Red Medium, Cadmium Yellow Medium, Cerulean Blue, Hooker's Green, Payne's Gray, Ultramarine Blue

Mediums Clearblend, Slowblend, Whiteblend

Brushes 2-inch (51mm) bristle flat, No. 12 bristle flat, No. 2 liner, 1½-inch (38mm) hake or ¾-inch (19mm) mop, ½-inch (12mm) comb, ⅜-inch (10mm) sable/synthetic angle, No. 2 fan, Tapered painting knife, Natural sea sponge

Pattern Enlarge the pattern (page 106) 154 percent.

Other 20" x 16" (51cm x 41cm) stretched canvas, Aerosol acrylic painting varnish, Black transfer paper, Hair dryer, Paper towels, Stylus, Ultrafine-point waterproof permanent marker or technical pen (black ink)

Color Mixtures

Before you begin, prepare these color mixtures on your palette.

Warm Gray	50 parts Whiteblend + 3 parts Ultramarine Blue + 3 parts Cadmium Red Light + 1 part Cadmium Yellow Medium
Light Blue	8 parts Whiteblend + 1 part Ultramarine Blue
Light Peach	40 parts Whiteblend + 1 part Cadmium Yellow Medium + 1 part Cadmium Red Medium
Grayed Peach	1 part Light Peach + 1 part Warm Gray
Teal	20 parts Whiteblend + 1 part Cerulean Blue
Seafoam	1 part Teal + 1 part Whiteblend + a touch of Cadmium Yellow Medium
Dark Violet	1 part Ultramarine Blue + 1 part Payne's Gray + 1 part Cadmium Red Light
Dark Green	2 parts Dark Violet + 1 part Hooker's Green
Brownish Green	Dark Green + various amounts of Burnt Umber
Slow-Clearblend	3 parts Clearblend + 1 part Slowblend (mix in a separate container)

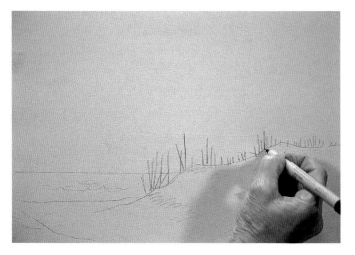

1 Prepare Your Canvas

Without washing your brush between colors, apply a generous amount of the Seafoam mixture over the bottom half of the canvas and a generous amount of the Teal mixture over the top half using your 2-inch (51mm) bristle flat. Blend the colors where they meet in the central portion of the canvas using the same brush. Allow this to dry and then transfer the pattern, omitting the birds (page 7).

2 Outline the Fence

Outline the fence posts with your ultrafine-point waterproof permanent marker or technical pen to preserve their placement.

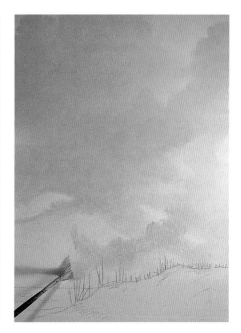

3 Lay In the Clouds at the Top Left

Working in small sections and beginning in the top-left portion of the sky, apply the Slow-Clearblend mixture with your 2-inch (51mm) bristle flat. While still wet, scumble irregular cloud shapes, being careful to leave spaces between formations, using your no. 12 bristle flat and the Warm Gray mixture, followed by touches of the Light Blue mixture. Slightly blend with your hake or mop. Moisten an adjacent section of the sky and continue in the same manner. If the paint begins to dry before you have time to blend, agitate it with a no. 12 bristle flat moistened with the Slow-Clearblend mixture. If your attempt is unsuccessful, wipe the cloud away with a clean, moist sponge and try again.

4 Paint More Clouds

Create the clouds in the top-right portion of the sky using the same technique and colors as in step 3, connecting the new formations with those on the left. Blend with your hake or mop as before. Moisten another area of the sky and repeat, adding and blending more clouds.

5 Add Vapor Trails and Smaller Clouds Along the Horizon

Using a no. 8 flat and the Warm Gray mixture, apply the bottom portions of the large formations, leaving large, irregularly shaped spaces between the clouds. Scumble vapor trail streaks along the bottom of the formations, randomly pulling your brush across the lower portion of the sky. Blend this slightly with a dry hake or mop. Paint the smaller clouds just above the horizon using a no. 8 flat and the Warm Gray mixture. Blend as before, then dry your canvas with a hair dryer.

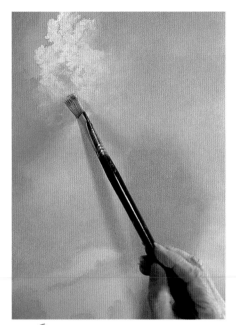

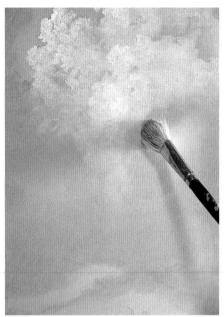

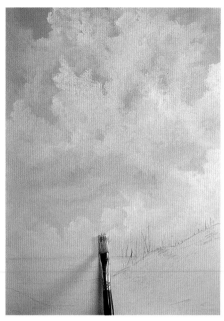

6 Add Highlights

Load one corner of a no. 2 fan with Whiteblend and the other corner with the Light Peach mixture. Load a no. 12 bristle flat with Clearblend, lightly wiping any excess from the sides of the brush. Start at the top of the sky and work down. Alternate the brushes to apply, then blend, a small portion of each cloud at a time. Begin with the no. 2 fan , applying dabs of the Light Peach mixture and White-blend along the edges of a small portion of a cloud at a time. While it's still wet, randomly tap into the colors using a no. 12 bristle flat, distributing the highlights throughout the clouds. Work from the outside in, moving your brush in multiple directions and leaving imperfections and spaces between taps. Highlights should be strongest along the outside edges of the clouds and should progressively fade as they move inward. Repeat, moving around each cloud until they are all highlighted.

7 Place Reflected Light

Using a no. 2 fan and the Grayed Peach mixture, dab reflected light in the shadow areas of the clouds. Tap to distribute the dabs in all directions using a no. 12 bristle flat moistened with the Slow-Clearblend mixture. Soften any hard edges with a dry hake or mop, lightly swishing the brush in multiple directions. Using the same brush, blend the areas where the highlights disappear into the shadows.

8 Create an Additional Layer of Clouds

Repeat steps 6 and 7, adding more highlights and reflected light to clouds throughout the sky. Leave spaces between cloud formations, then add more highlights or reflected light to suggest a layer of clouds in front of the already established clouds. Tap the paint, distributing it in dabs. Connect the clouds in front of the background formations by tapping the top of a cloud's highlight and moving your taps upward until they touche the lower portions of a previously painted cloud. Soften and blend as before.

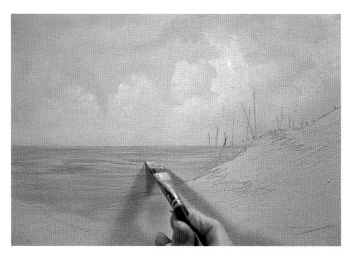

9 *Establish the Water*

Moisten the water area with a no. 2 fan and the Slow-Clearblend mixture. Using your comb brush, apply horizontal streaks of the Warm Gray mixture along the horizon line and sandy shore. Also add a few random dashes in the water. Add streaks of both the Teal and Light Blue mixtures in the central water area. Be sure to leave some of the Seafoam basecoat showing through. Quickly move on to the next step before the paint dries.

10 *Paint the Whitecaps*

Apply, then soften one whitecap at a time. Draw a short, uneven line of Whiteblend horizontally through the water using a no. 2 liner. Touch the bottom edge of each Whiteblend stroke with your fan brush, distributing the paint with a downward, horizontal swooping motion across the water to create a curl under the crashing waves. Blend the side edges of the whitecaps horizontally out from the wave using a comb. Make the foremost whitecap larger and bolder by applying a heavier line of Whiteblend and making the swoop more pronounced.

11 *Define the Tide Line*

Paint the tide line at a slight angle across the beach using your liner brush and Whiteblend. Horizontally stroke the top edge of this line with a comb brush moistened with the Slow-Clearblend mixture. With a series of successive strokes, move your brush along the top side of the tide line, making it appear as though it is receding back into the ocean.

12 *Lay In the Dune*

Moisten the dune area with a no. 2 fan and the Slow-Clearblend mixture. Using the same brush and following the slope of the sand, apply streaks of both the Teal and Light Blue mixtures to indicate the reflected light on the dune. Add the Dark Violet mixture to your brush and apply deep shadows in the foreground. Add the Warm Gray mixture to this to create the lighter shadows on and around the dunes.

13 Highlight the Dune

Using your angle brush, add highlights to the dune alternating between the Light Peach mixture and Whiteblend. Slightly blend the edges of the highlights into the shadows using a comb brush moistened with Clearblend. Stroke in the direction of the sand drifts, leaving a variety of light and dark streaks.

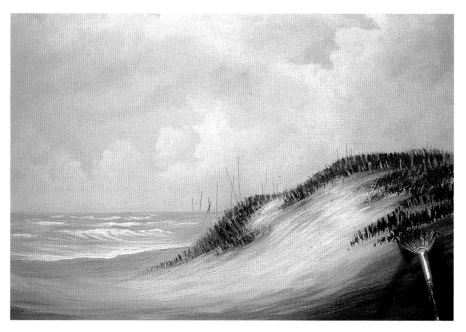

14 Establish the Grass

Using a no. 2 fan lightly loaded with the Warm Gray mixture, establish the most distant grass on the crest of the dune with short, downward strokes. Likewise, place random clumps of the Dark Green and Brownish Green mixtures on the grass and around the remainder of the dune.

15 *Add Shadows to the Grass*

Using a comb brush moistened with the Slow-Clearblend mixture, create shadows beneath the grass by pulling some of the wet paint from the grass roots across the dune. Make your strokes according to the slope of the drifting sand.

16 *Place Reflected Light*

Apply reflected light on the most distant dune grasses at the crest of the hill using a no. 2 fan and the Teal mixture.

17 *Paint the Tall Grass*

Add random, upward strokes to indicate taller blades of grass in the foremost grassy areas using a liner and watery Dark Green mixture. Add a few tall clusters in other grassy areas as well. Let dry. Then add a few more blades of grass in all areas with the liner double loaded with the Dark Green and Teal mixtures.

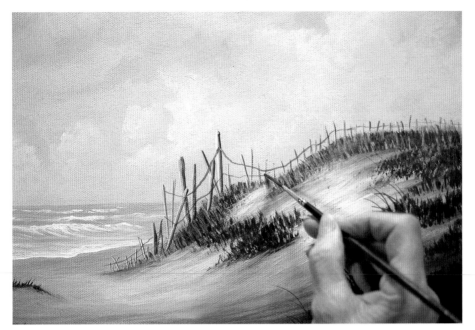

18 *Paint the Fence*

Paint the fence using a liner double loaded with a mixture of Burnt Umber and the Warm Gray mixture on one side and the Light Peach mixture on the other. Add more Burnt Umber for the taller, central fence slats, and more Warm Gray mixture for the shorter fence on the crest of the hill. Paint the wires using the tip of a liner and a watery mixture of Burnt Umber and the Warm Gray mixture.

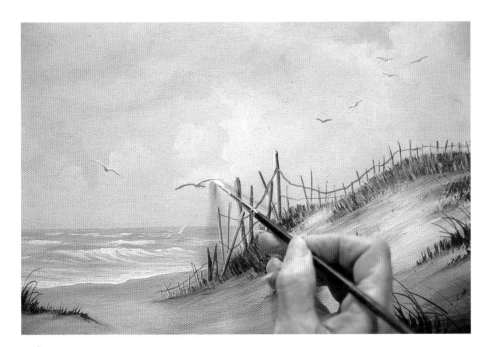

19 *Add the Birds*

Paint the birds using a liner double loaded with a brush-mixture of the Dark Violet mixture and Whiteblend on the bottom and Whiteblend on the top. Starting at the the tip of a bird's wing, pull your brush inward, then press down to create a larger shape for its body. Lift up slightly and drag the point of the brush outward to create the second wing. Paint as many birds as you'd like, flying at different angles. Let this dry. Add the foreground bird's eyes and primary feathers with a liner and thinned Payne's Gray. Paint the beaks using the same brush and watery Cadmium Red Light. Sign your painting, then spray it with aerosol acrylic painting varnish once it is thoroughly dry. Enjoy your sky-high creation of beautiful clouds!

The Bunkhouse

Early morning light on the season's first blanket of snow is a magnificent sight. The most humble of settings can become the most beautiful when draped in fresh snow. Here, an old barn and bunkhouse, which typically look neglected in warm weather, serve as the centerpiece of a glorious and serene winter scene.

Starting with a basecoated canvas, you will practice creating depth by changing values, progressing from lighter to darker as you move toward the foreground. By repeatedly adding layers of clouds, trees, meadows and fences, you will transform a solid-color canvas into a painting of convincing depth.

A trickle of smoke from the chimney adds a warm touch to the painting, leading you to imagine those inside starting their day by the fire. Why, you can almost smell the biscuits in the oven, the bacon in the pan and the coffee in the kettle. There's always an ample supply of food on the farm; maybe they'll invite us to join them for a hearty breakfast!

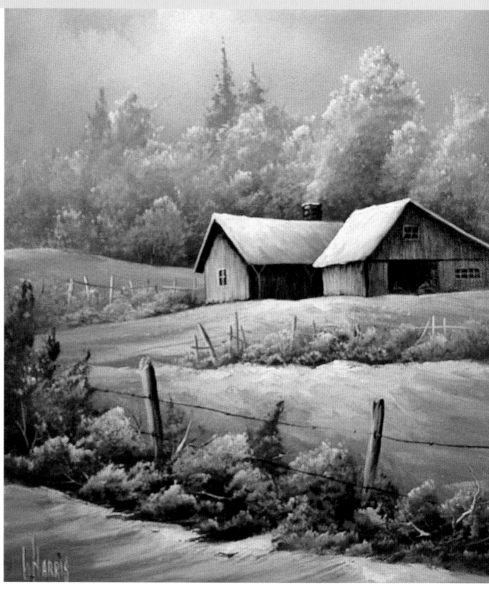

The Bunkhouse
14" x 18" (36cm x 46cm)

Materials

Acrylic Colors Burnt Umber, Cadmium Red Medium, Cadmium Yellow Medium, Cerulean Blue, Dioxazine Purple, Titanium White, Yellow Ochre

Mediums Clearblend and Whiteblend

Brushes 2-inch (51mm) bristle flat, Nos. 8 and 12 bristle flats, ¼-inch (6mm) sable/synthetic flat, No. 12 bristle round, No. 2 liner, 1½-inch (38mm) hake or ¾-inch (19mm) mop, ½-inch (12mm) comb, ⅜-inch (10mm) sable/synthetic angle, No. 2 fan, Tapered painting knife

Pattern Enlarge the pattern (page 107) 185 percent.

Other 14" x 18" (36cm x 46cm) stretched canvas, Adhesive paper, Aerosol acrylic painting varnish, Stylus, White transfer paper

Color Mixtures

Before you begin, prepare these color mixtures on your palette.

Cream	Whiteblend + a speck of Yellow Ochre
Creamy Peach	Whiteblend + a touch of Cadmium Red Medium + a touch of Yellow Ochre (Make a light and a medium value)
Thick Peach	Titanium White + a touch of Cadmium Red Medium + a touch of Cadmium Yellow Medium
Medium Blue-Green	5 parts Burnt Umber + 3 parts Cerulean Blue + 20 parts Whiteblend
Dark Blue-Green	3 parts Burnt Umber + 1 part Cerulean Blue
Dusty Gray-Green	4 parts Whiteblend + 3 parts Burnt Umber + 1 part Cerulean Blue
Light Gray-Green	1 part Dusty Gray-Green mixture + 1 part Cream mixture
Brown-Green	4 parts Burnt Umber + a touch of Dioxazine Purple
Dark Brown	10 parts Burnt Umber + a touch of Dioxazine Purple
Violet-Gray	6 parts Whiteblend + 2 parts Dioxazine Purple + 1 part Cerulean Blue

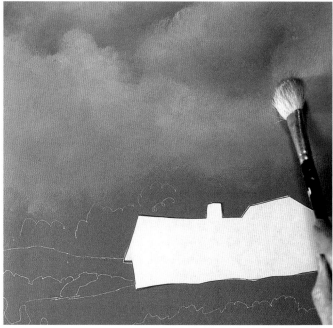

1 Prepare Your Canvas

Apply a basecoat of Dusty Gray-Green mixture to your canvas using your 2-inch (51mm) bristle flat. Let this dry, then transfer your sketch (page 7). Cover the buildings with a design protector (page 7) before moving on.

2 Establish the Sky

Moisten the sky with a 2-inch (51mm) bristle flat and Clearblend. Then using your bristle round, randomly apply the Light Gray-Green mixture throughout the sky, creating cloud-like shapes. Add shadows at the bottom of the clouds with the Dusty Gray-Green mixture, blending to create a gradual transition of color and value. Next, add a touch of the Cream mixture to the tip of your brush. Holding the brush at an angle close to the canvas, tap and swirl the brush along the top of the light gray-green shapes to create highlights. Blend the bottom of these highlighted areas, leaving the top of the clouds full and puffy.

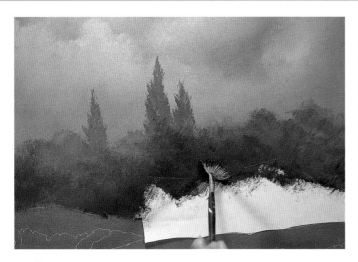

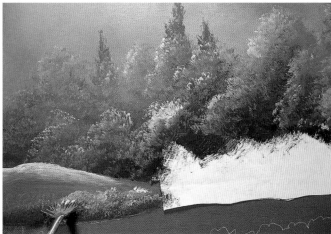

3 Create the Fir Trees and Block In the Background Foliage

With the bristles of a no. 2 fan turned vertically, stipple the tops of the fir trees with Medium Blue-Green mixture. Work your way downward, leaning the brush this way and that to widen the bottoms of the trees. With the same brush and mixture, scumble the bases of the fir trees into the deciduous foliage below. Continue tapping and scrubbing to apply the base for the deciduous trees, creating a gradual transition in value by adding the Light Gray-Green mixture to the uncleaned fan brush. Make the tree bases incrementally darker by adding the Medium Blue-Green mixture followed by the Dusty Gray-Green, Dark Blue-Green and Dark Brown mixtures.

4 Continue Developing the Foliage and Paint the Distant Meadow

Sparingly stipple and crunch the Violet-Gray mixture throughout the distant trees with a no. 12 flat, then stipple highlights with the Medium Blue-Green mixture on the tops of tree clusters using your bristle round. Add the Cream mixture to the top edge of your bristle round and crunch additional highlights along the tops of the foliage. Use the corner of your no. 2 fan to apply the same colors on the fir trees. Next, moisten the meadow in front of the distant foliage using a no. 8 flat and Clearblend. Add streaks of the Medium Blue-Green and Violet-Gray mixtures in the lower portion of the meadow using a no. 2 fan. Don't paint solidly: leave plenty of basecoat showing. Apply a small amount of the Cream mixture along the crest of the meadow with a clean no. 2 fan, then blend the bottom edges with a no. 8 flat. Establish the foliage along the distant fence line using the same technique and colors used to define the distant trees.

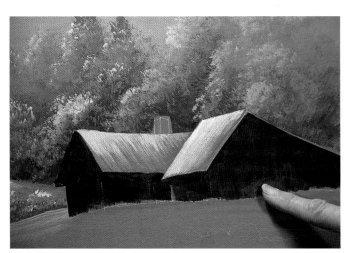

5 Apply Roof and Barn Basecoat

Apply the roof basecoat one section at a time with your angle brush. Use the Violet-Gray mixture in the lower portion and a marbleized mixture of Whiteblend with a touch of Creamy Peach along the top. Blend in the direction of the roof's slant using your comb brush. Next, apply a basecoat to the eaves and barn siding using your angle brush and the Dark Brown mixture . Blot with your finger to remove some of the paint in the lower portion of the open door.

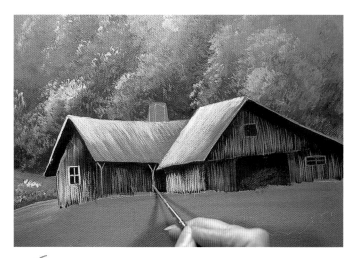

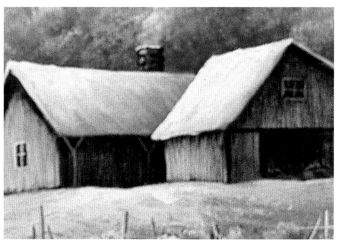

6 Add Woodgrain Highlights, Moldings and Posts

Avoiding the eaves and door, streak the Dusty Gray-Green mixture vertically over the wood siding using your comb brush. Clean your brush and streak creamy highlights on the sunlit portions of the buildings, leaving the shadows underneath the roof. Darken window panes and touch up the eave shadows using your sable/synthetic flat and the Dark Brown mixture. Add the moldings and posts using a liner with the Medium Blue-Green mixture in the shadowy areas and the Marbleized Creamy Peach mixture on the sunlit side.

7 Paint the Chimney and Highlight the Roof

Paint the chimney with your ¼-inch (6mm) flat and the Dark Brown mixture. Add the Dusty Gray-Green mixture to the uncleaned brush and insert tiny, irregularly shaped dabs on the right side of the chimney to indicate stones. Use the Creamy Peach mixture to create the stones on the left side. Place snow on top of the chimney using your liner loaded with the Violet-Gray mixture for the shadow and Whiteblend for the highlight. Then, moisten the roof with Clearblend and the no. 8 bristle flat. Highlight the top using your angle brush loaded with Titanium White and touches of the Marbleized Thick Peach mixture. Blend the lower portions of the highlights into the gray area with the no. 8 bristle flat, being careful to preserve some violet-gray shadows around the edges.

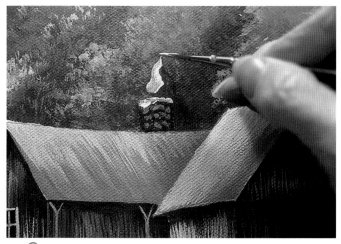

8 Add Smoke

Apply a zigzag streak of smoke coming from the chimney using your liner double loaded with the Medium Blue-Green mixture on the bottom and the Cream mixture on the top. Smear the wet paint across the trees, leaving light and dark streaks. The smoke should fade into the trees as it moves upward.

9 Establish the Middle-Ground Meadow

Moisten the ground in front of the buildings using a no. 2 fan and Clearblend. While wet, add the Creamy Peach mixture to the area with your painting knife. Still using your painting knife, scrape Titanium White over select areas of the Creamy Peach mixture, following the slope of the land.

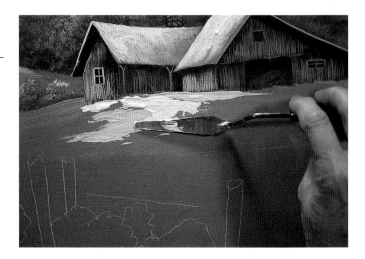

10 Blend the Middle-Ground Meadow

Blend the Creamy Peach mixture and Titanium White outward, according to the slope of the hill, using a comb brush moistened with Clearblend. Again, don't paint solidly. Leave plenty of the basecoating showing, especially in the valleys. Use your painting knife to sparingly scrape Violet-Gray and Medium Blue-Green streaks across the meadow, suggesting reflected light. Blend as before.

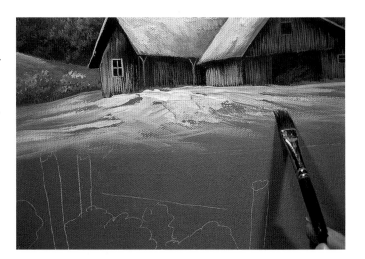

11 Define the Middle-Ground Foliage

Using your no. 8 bristle flat, stipple the foliage in front of the middle-ground fence. Start with the Light Gray-Green mixture for the tops of the foliage, followed by the Medium Blue-Green, Dusty Gray-Green and Dark Blue-Green mixtures. Add the Cream and a speck of the Creamy Peach mixture to the top edge of your uncleaned brush, then stipple and crunch highlight on the tops of the foliage clusters.

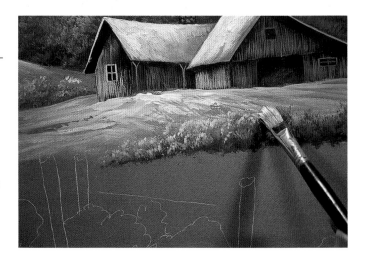

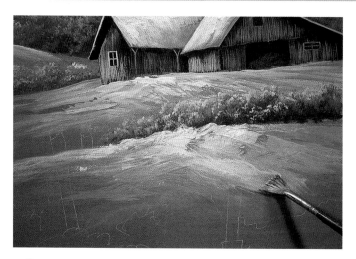

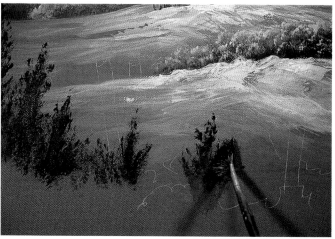

12 Paint the Foreground Meadow

Moisten the meadow in the foreground using a no. 2 fan and Clearblend. Sparingly scrape shadows with the Violet-Gray mixture and reflected light with the Medium Blue-Green mixture across the meadow with your tapered painting knife, then blend the edges according to the slope of the hill. As always, do not paint solidly. Leave spaces between the streaks, allowing the basecoat to show through. Generously trowel highlights with the Thick Peach mixture on the central crest of the meadow using your tapered painting knife. Scrape the outer edges of the paint across the meadow with your painting knife, following the slope of the land. Blend the edges with a comb brush moistened with Clearblend. Apply Titanium White highlights along the crest of the hill in the wet peach areas with your tapered painting knife to help indicate the dimension of the meadow. Scrape and blend as before.

13 Create the Foreground Foliage

Stipple the tall, pointed foliage in front of the foreground fence using your fan brush and alternating between the Dark Blue-Green and Brown-Green mixtures. Stipple the rest of the foliage using your bristle round and the same colors.

14 Place Reflected Light

Add the Violet-Gray mixture to the top side of your uncleaned bristle round and randomly crunch in the reflected light on the foreground foliage. Add the Medium Blue-Green mixture to the top of the same brush and crunch more reflected light on the tops of foliage clusters.

15 *Apply Highlights to the Foreground Foliage*

Now add the Cream mixture to the top side of the uncleaned bristle round, then stipple and crunch highlights on the tops of the foliage clusters. In the same manner, sparingly place a few touches of the Creamy Peach mixture on the clusters for added dimension.

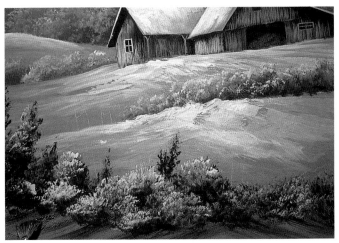

16 *Establish the Shadows Beneath the Foreground Foliage*

Moisten the area beneath the foreground foliage using your fan brush and Clearblend. Then with your no. 8 bristle flat, streak shadows across the moist hill with the Dark Blue-Green mixture, starting at the base of the foreground foliage and pulling the brushstrokes in the direction of the slope.

17 *Add Snow*

Apply and blend the snow in front of the foreground foliage using the same colors and technique used to paint the foreground meadow in step 12.

18 *Define the Distant and Middle-Ground Fences*

Brush-mix the Dark Brown and Dusty Gray-Green mixtures with your liner to create a medium tan color. Then add the Cream mixture to the top of the brush. Paint the fence posts with the double-loaded liner, placing the Cream mixture on the top and left sides of the boards and medium tan on the right sides.

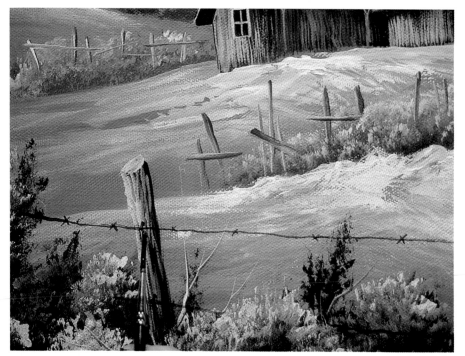

19 *Paint the Foreground Fence*

Paint one foreground fence post at a time. Using your angle brush to make short, choppy, vertical strokes, apply a base on the right sides of the posts with the Dark Brown mixture. Add the Creamy Peach and Cream mixtures to your brush to create the highlights on the left sides of the posts, pulling your brush to the right so the highlights slightly overlap the base. Let it dry and touch it up if needed. Add the barbed wire using a liner and a rusty brown color made with Burnt Umber and a touch each of Cadmium Red Medium and Cadmium Yellow Medium.

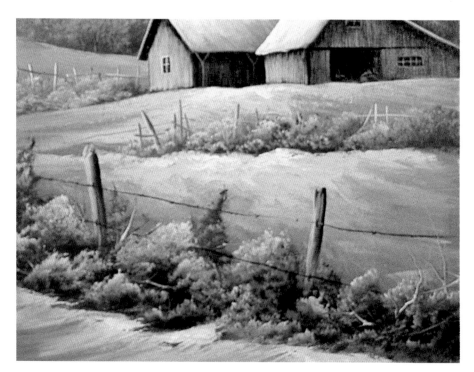

20 *Add Twigs and Other Finishing Touches*

Using a liner double loaded with the same colors used to paint the fence posts, add a few twigs and limbs in the foreground foliage. Create the illusion of hay bales and tools in the barn (in front of the door) with the dark and light values used on the fence and barbed wire. Sign your painting and let it dry, then spray with aerosol acrylic painting varnish. Now you can sit back and enjoy the beauty of the fresh snow on the bunkhouse year-round!

Tickled Pink

Acrylics are a wonderfully versatile medium. They can be used on any non-oily surface, including cold-pressed watercolor paper, as in this demonstration.

You can easily simulate the appearance of transparent watercolors with acrylic paints by simply adding water to your mix. In fact, sometimes it's more beneficial to use acrylics to create a watercolorlike painting than it is to use actual watercolors. For example, if you want to layer colors without affecting previous applications, acrylics are a suitable choice. When watercolors are re-wet they reopen, making colors run, bleed and blend. However, if you use acrylics you can re-wet your paper without worrying about disturbing previous washes. Moreover, acrylics keep their brilliance and do not fade when they dry. Better yet: deep, dark, rich colors can be achieved more quickly and effectively with acrylics or acrylic/watercolor blends than with traditional watercolors. With so many benefits, it's easy to see why so many artists work with acrylics. Other mediums simply can't match their versatility!

Tickled Pink
14" x 10" (36 cm x 25cm)

Materials

Acrylic Colors Cadmium Red Medium, Cadmium Yellow Medium, Hooker's Green, Payne's Gray, Phthalo Crimson, Ultramarine Blue

Medium Whiteblend (optional)

Brushes ¼-inch (6mm) sable/synthetic flat, No. 2 round, No. 2 liner, 1½-inch (38mm) hake or ¾-inch (19mm) mop, ½-inch (12mm) comb, ⅜-inch (10mm) sable/synthetic angle, No. 2 fan, Tapered painting knife, Natural sea sponge

Pattern Enlarge the pattern (page 108) 112 percent.

Other 14" x 10" (36cm x 25cm) sheet of 140-lb. (300gsm) cold-pressed watercolor paper, Cotton swabs, Liquid soap, Masking fluid and an old round brush for application, Spray bottle, Stylus, Watercolor palette, White transfer paper

Color Mixtures

Before you begin, prepare these color mixtures on your palette.

Dark Green	Water + 1 part Payne's Gray + 1 part Hooker's Green
Magenta	Water + 1 part + Phthalo Crimson + 1 part Cadmium Red Medium
Purple	Water + 1 part Ultramarine Blue + 1 part Phthalo Crimson

2 *Prepare Your Watercolor Paper*

Transfer the design (page 7), placing the flower in the top-left corner of your paper. Wet your old round brush, then saturate the bristles with liquid soap. Gently wipe off the excess soap and water, then dip the brush in masking fluid. Apply this along the inside edges of the petals, stamen, leaves and stems. When all the areas have been masked, wash your brush thoroughly with soap and water and rinse well. Allow the masking fluid to dry before you begin painting, and refill your water container with clean water.

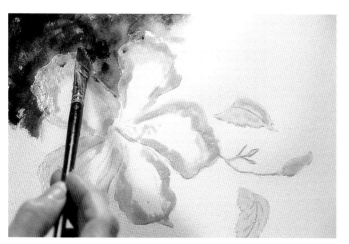

1 *Prepare Your Palette*

Place a pea-sized dollop of Cadmium Yellow Medium, Phthalo Crimson and each color mixture in its own well on the watercolor palette. Fill each cup half full of water and agitate the edge of the paint, dissolving it into the water. Be sure to test colors on scrap paper before you begin painting.

3 *Lay In the Shadowy Background In the Top-Left Corner*

Wet the top-right area of the background with your no. 2 fan. Generously but unevenly apply dabs of Dark Green behind the top three flower petals, overlapping into the wet area using your angle brush. Be careful not to paint solidly. Leave some spaces for additional colors. Then, randomly drop several small dabs of Magenta, Dioxazine Purple and Ultramarine Blue into the Dark Green using your ¼-inch (6mm) flat.

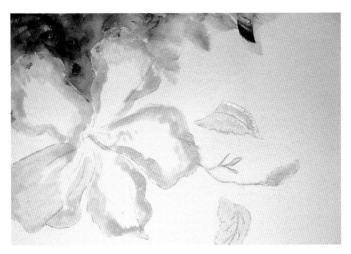

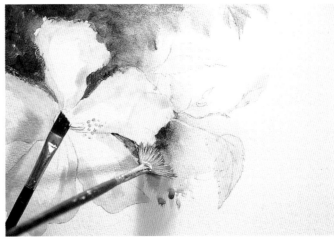

4 Create the Illusion of Leaves

While still wet, blend the right edges of the background paint with your no. 2 fan. Using a wet comb brush, pull a small amount of paint from the edge of the background color to create pale, watery leaf shapes along the top of the paper.

5 Lay In the Shadowy Background to the Right

Using a no. 2 fan and clean water, moisten the paper on the right side of the flower where you want the colors to disperse. Dab background colors adjacent to the flower petals, overlapping the wet area. Immediately blend with a no. 2 fan, pulling the colors away from the flower petals and making them disappear around the leaves.

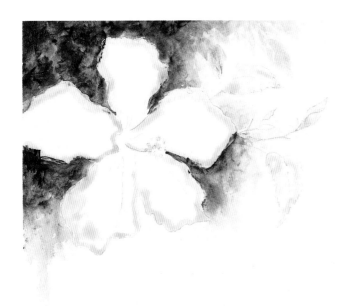

6 Establish Shadows Beneath the Petals

Place your paper upright or on a slanted surface with the top elevated. Leave small areas adjacent to the bottom petals dry, wetting the remaining bottom section by spattering water with a no. 2 fan. Still using the same colors from step 3, lay color on the petals overlapping the wet area using an angle brush. Immediately disburse the bottom area of the wet paint by splashing, splattering and dragging the lower portions with a dripping wet no. 2 fan. Create a gradual transition of colors and irregular-shaped drips and runs.

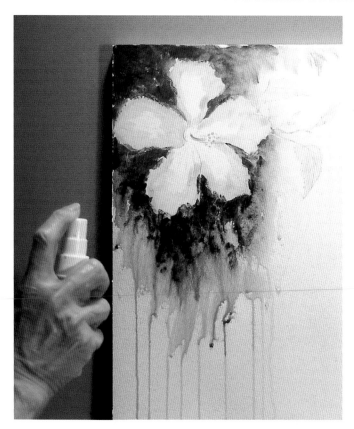

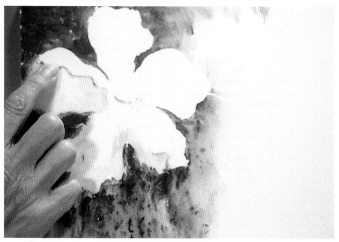

8 Remove the Masking

Remove most of the masking from the flower, leaving only the flower's pistil and stamen protected. Rub the edges of the masking to loosen it, then lift it from the paper. Roll the remains into a ball and discard.

7 Create Dramatic Runs

Dab more paint in and around the runs as needed. Allow the additional paint to drip, strengthening the existing color. Create dramatic and uneven drips and runs by squirting the wet paint with your spray bottle. Direct the runs as needed with the point of your round brush. Remove any excess water with a barely damp sponge. Use cotton swabs in tight spaces.

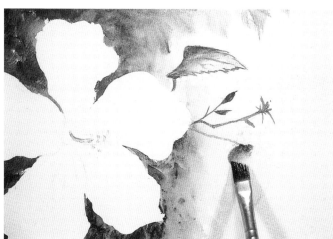

9 Paint the Stems and Leaves

Paint the tops of the stems and calyx using a no. 2 liner and Cadmium Yellow Medium. Allow the yellow on the stems to dry almost completely. While just barely damp, paint the bottom of these stems using the Dark Green mixture. Allow your paper to dry thoroughly, then paint and blend the large leaves one at a time. Dampen the light area using your comb brush and clean water. With the same brush, apply watery Dark Green mixture in the dark areas closest to the flower. Extend the color over the light area using a clean comb brush and clean water. Quickly remove unwanted color with a cotton swab. Repeat for all leaves and let your paper dry.

10 *Add Leaf Details*

Barely moisten the leaves using a clean, wet angle brush. Paint veins on the large leaves with a no. 2 liner and a very watery Dark Green mixture, blotting with your finger to subdue. Let this dry.

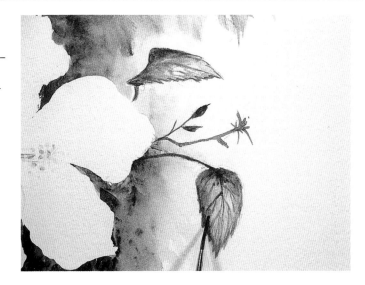

11 *Paint the Petals*

Dampen each petal individually using your comb brush and clean water. Apply a translucent application of the Magenta mixture along the outer portions and in the shadowy areas of each petal using your angle brush. Blend using the same brush, leaving the central area of the petals with very little color. Let this dry.

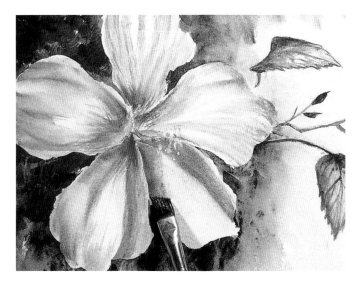

12 *Further Develop the Petal Shadows*

Strengthen petal shadows by laying a light, translucent wash of watery Purple mixture with your angle brush. Blend with your comb brush, taking care not to cover too much of the Magenta mixture. Quickly remove any excess with a cotton swab. Repeat for all petals and allow your paper to dry.

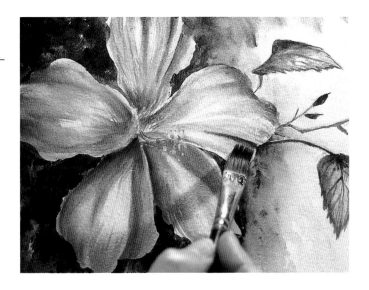

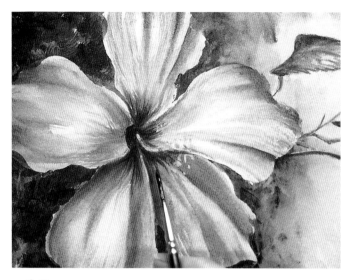

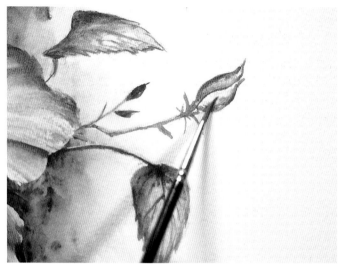

13 Apply Shadows to the Throat of the Flower

Using your angle brush and clean water, moisten the petals of the flower, leaving only the throat dry. Create shadows in the throat area using your round brush and a mixture of Payne's Gray and the Magenta mixture. Slightly pull the edges of the wet shadow outward, radiating with a star-burst effect from the center.

14 Paint the Bud

Moisten the light areas on the bud with clean water and your sable/synthetic flat. Apply the Magenta mixture and blend. Add a touch of watery Purple mixture to your brush to strengthen some shadows, then blend with a no. 2 round. Let dry.

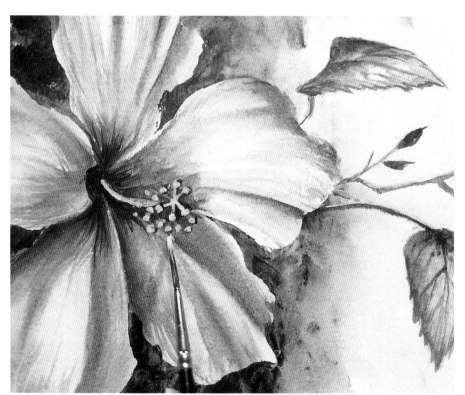

15 Paint the Pistil and Stamen

Remove the remaining masking from the pistil and stamen. Paint the pistil and stamen dots with a no. 2 liner and Cadmium Yellow Medium. Let this dry. Using a small amount of the Purple and Magenta mixtures mixed on the tip of a no. 2 liner, add shadows underneath some of the stamens, separating them from the crossed pistils. If seepage occurs and the stamen and pistil are lost or discolored, add a touch of Whiteblend to the Cadmium Yellow Medium to correct the problem. Sign your painting and let it dry. Mat and frame the final product and be tickled pink with your success!

End of Summer

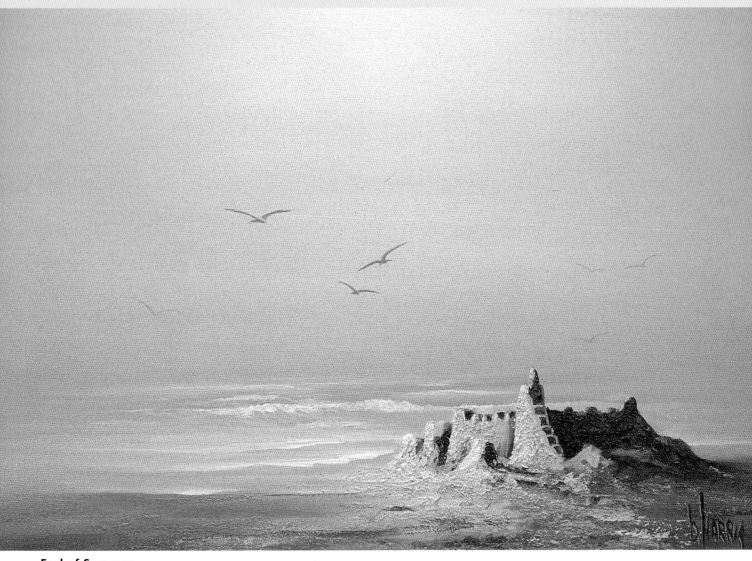

End of Summer
14" x 18" (36cm x 46cm)

Being a grandmother who lives in Florida near the ocean, I have years of experience building sand castles. At the end of every summer, my granddaughter and I leave one standing for the tide to erase. This tradition inspired me to paint this composition.

Adding texture to your paintings is fun. You can add sand that you collected to your paint, as I did for this book demonstration, or you can try the many textured acrylic paints on the market.

You also can add a variety of other objects such as paper for collage, buttons, bows and ribbons—to name only a few. Acrylic paint works somewhat like glue when it dries, hardening to hold whatever is added.

After you have completed this composition, consider what else you might add to your paint besides sand to create texture and interest. You are limited only by your imagination, but remember that an artistic genius lies within you. Stretch your mind and give texture a try!

Materials

Acrylic Colors Burnt Sienna, Burnt Umber, Cadmium Red Light, Cadmium Yellow Medium, Cerulean Blue, Dioxazine Purple, Titanium White, Ultramarine Blue

Mediums Clearblend, Slowblend and Whiteblend

Brushes 2-inch (51mm) bristle flat, Nos. 8 and 12 bristle flats, ¼-inch (6mm) sable/synthetic flat, No. 2 liner, 1½-inch (38mm) hake or ¾-inch (19mm) mop, ½-inch (12mm) comb, No. 2 fan, Tapered painting knife,

Pattern Enlarge the pattern (page 109) 143 percent.

Other 14" X 18" (36cm x 46cm) stretched canvas, Aerosol acrylic painting varnish, Black transfer paper, Paper towels, Sand (or textured paint), Stylus

Color Mixtures

Before you begin, prepare these color mixtures on your palette.

Peach	10 parts Whiteblend + 1 part Cadmium Yellow Medium + 2 parts Cadmium Red Light
Off-White	Whiteblend + a speck of Peach
Deep Blue	3 parts Cerulean Blue + 1 part Ultramarine Blue
Light Sea Green	5 parts Titanium White + 5 parts Peach + 1 part Deep Blue
Medium Blue	1 part Deep Blue + 1 part Light Sea Green
Blue-Gray	8 parts Whiteblend + 3 parts Ultramarine Blue + 1 part Burnt Sienna + 1 part Dioxazine Purple + a touch of Slowblend
Beach Shadow	2 parts Dioxazine Purple + 2 parts Burnt Umber + 1 part Ultramarine Blue + a touch of Peach
Textured Beach Shadow	3 parts Beach Shadow + 1 part sand
Textured Pale Peach	5 parts Titanium White + 1 part Cadmium Yellow Medium + 2 parts Cadmium Red Light + 4 parts sand
Textured Bright Peach	3 parts Textured Pale Peach + a touch of Cadmium Yellow Medium + a speck of Cadmium Red Light + 1 part sand
Textured Blue-Green	4 parts Light Sea Green + 3 parts Titanium White + 1 part Ultramarine Blue + 2 parts sand
Textured White Quartz	3 parts Titanium White + 1 part sand

1 Apply the Peach to the Sky

Apply generous streaks of the Peach mixture wet-next-to-wet throughout the central and lower sky area using a 2-inch (51mm) bristle flat.

2 Paint the Sky and Underpaint the Ocean

Paint the remainder of the sky area with a clean 2-inch (51mm) bristle flat and the Light Sea Green mixture, overlapping the outer edges of the wet Peach paint. Blend the colors with the fan where they connect and overlap; complete the final blending with the mop or hake. Paint the water and beach area while the sky is still wet using a 2-inch (51mm) bristle flat. Begin at the bottom of the wet sky; paint the Light Sea Green mixture in the ocean area, overlapping the bottom edge of the sky. Overlap the bottom of the wet ocean paint with the Peach mixture, stroking horizontally to the bottom of the canvas.

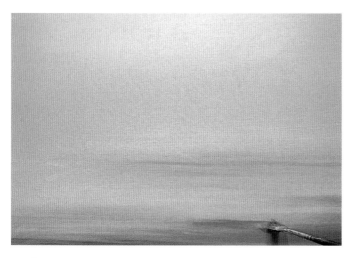

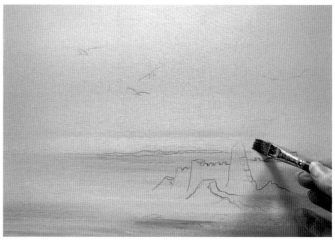

3 Create Water and Beach Shadows

Create shadows by streaking the Medium Blue mixture horizontally through the center of the ocean with the fan brush. Darken the foreground beach and add a few streaks through the central sand area on the wet beach using the Beach Shadow mixture loaded on the fan. Let dry.

4 Paint the Horizon Water Line

Transfer the sand castle (page 7). Place the tallest point of the castle approximately 10¾ inches (27cm) down from the top and 5¾ inches (15cm) in from the left side of the canvas. Apply Clearblend over the water with the fan. Stroke a 6-inch (15cm) horizontal strip along the crest of the water at the horizon using the angle brush and an equal brush mixture of Whiteblend and Clearblend; end approximately 5 inches (13cm) short of both sides of the canvas. Blend both sides and the bottom edge of the glaze with horizontal strokes of the comb brush, creating a gradual transition in value and leaving a faint glow in center of the horizon. Let dry.

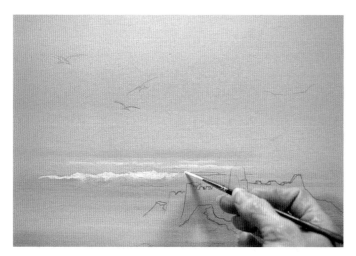

5 Apply the Whitecaps

Moisten the water with Clearblend using the no. 2 fan, and blend one wave at a time. Streak the Medium Blue mixture horizontally through the center of the wave with the ¼-inch (6mm) flat to establish the shadow of the waves. Blend the edges with the comb brush. Paint uneven lines of Whiteblend along the top of the wave shadow using the no. 2 liner to create the whitecap. Add random touches of the Off-White mixture to the Whiteblend. While the waves are still wet, move on to the next step.

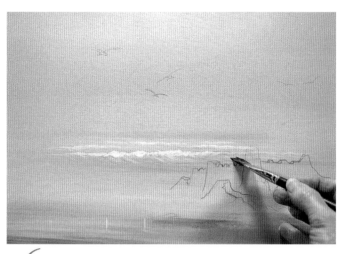

6 Direct the Spill

Pull the bottom of the whitecap across the wave shadow using the comb brush; use a backwards, comma stroke to create the direction of the spill. Stroke the water horizontally at the base of the wave, making it lie flat. Soften the side edges of the whitecap, creating a gradual transition on both sides with the comb brush. Repeat for each wave, making each wave slightly larger and bolder as they move forward. Let dry. Cover the foremost wave with Clearblend. Add squiggly foam lines conforming to the face of the wave using the no. 2 liner and a brush mixture of Whiteblend and Clearblend. Blend with the comb brush and let dry.

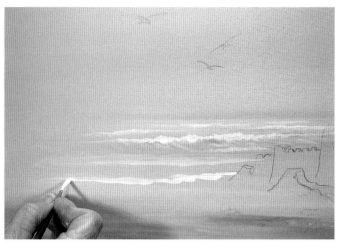

7 Apply the Tide Lines

Moisten the foreground water and sand with Clearblend. Draw an uneaven tide line across the beach using Whiteblend with touches of the Off-White mixture loaded on the no. 2 liner. Blend the wet receding the lines with a Clearblend-moistened comb brush.

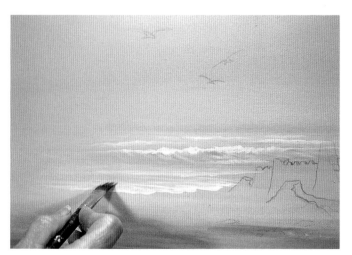

8 Blend the Receding Tide Lines

Blend horizontally using the comb brush, starting at the top edge of the tide line, making each subsequent stroke higher on the canvas. Move the top of the tide line back into the ocean. Leave the leading edge undisturbed on the beach. Repeat for all tide lines. Let dry. If needed, deepen the shadows underneath the tide by covering the sand and tide lines with Clearblend. Then apply dashes of the Peach mixture mixed with a touch of the Medium Blue mixture underneath the leading edge of the tide lines. Blend the color horizontally, gradually moving it down from the tide line toward the beach. If the shadow color gets on the tide line, remove it with a clean ¼-inch (6mm) flat moistened with Clearblend.

9 Paint the Foreground Birds

Paint the foremost gulls using the Blue-Gray mixture. Highlight the tops of the wings, heads, backs and tails using a brush-mixture of Whiteblend and a touch of the Peach mixture loaded on the liner. Paint the beaks using a watery mixture of Cadmium Red Light and a touch of Whiteblend loaded on the liner. Paint the eyes with a tiny dot of Burnt Umber on the tip of the liner.

10 Paint the Distant Birds

Add a touch of Whiteblend to the Blue-Gray mixture. Apply a few lighter, smaller birds in the distance.

11 Paint the Sand Castle

Apply the Textured Beach Shadow mixture in the dark areas of the sand castle with the ¼-inch (6mm) flat, using the photograph of the finished painting (page 90) for color placement. Pile the paint on heavily. Highlight the sand castle where the sun hits it by alternating the Textured Pale and Bright Peach mixtures; add a touch of the Textured White Quartz mixture occasionally. Blend between the shadows and highlights to create soft, rounded edges; then leave some sharp, angled edges. Let dry. Apply smaller structures in front of the sand castle using the same colors, brush and technique.

12 Add Highlights

Highlight along the top and left sides of the sand castle using the Textured Pale and Bright Peach mixtures loaded on the liner.

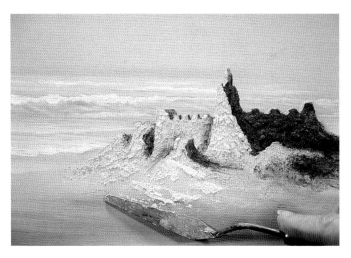

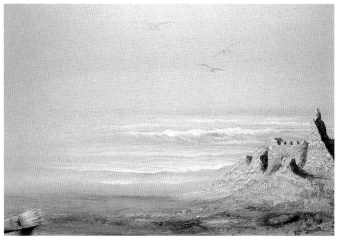

13 Apply Textured Sand

Spread the colors from the sand castle over the foreground area with the palette knife; place the colors according to the photograph of the finished painting (page 90).

14 Blend the Textured Sand

Add the Textured Blue-Green mixture over the other foreground colors. Blend the outer edges of the sand horizontally over the beach with the no. 12 bristle flat moistened with Clearblend. Let dry.

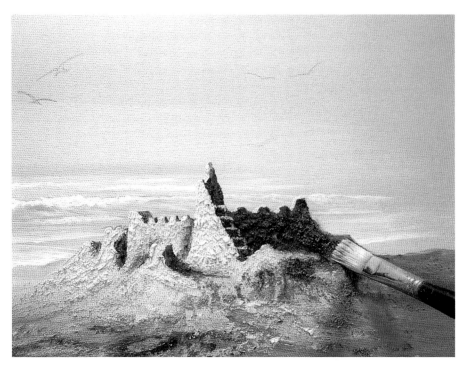

15 Create the Steps and Reflected Light

Paint the illusion of steps using the no. 2 liner loaded with the Peach mixture for the top of each step and Textured Blue-Green mixture for the reflected light on the right sides of each step. Paint the reflected light over the shadowed area of the sand castle by using a light touch and very little Textured Blue-Green mixture loaded on the no. 12 bristle flat. Sign your painting. Dry thoroughly. Spray your painting with aerosol acrylic painting varnish, and take a stroll along your favorite beach before the "end of summer."

Conclusion

I hope you have enjoyed completing the projects in this book and watching the *Painting With Brenda Harris* TV series. I hope they are an enjoyable memory in your fun, artistic, learning journey. I also hope you have mastered some techniques giving you greater skills to go forward with your own ideas and compositions.

The more you give, the more you get. If you help others get what they want and need in life, your needs will be met. This is life's reward for sharing. As I have shared with you, I hope you will share with others. Painting is an unmatched joy. Encourage your family and friends to participate; help someone special get started.

Art teaching programs bring great joy to all who watch. Many never pick up a brush, but paint along in their minds. That is OK. The mental exercise satisfies our minds, hearts and souls. Happy, creative thoughts help to keep us alive and thriving. Contact your PBS station; thank them for airing *Painting With Brenda Harris*, as well as other art shows you enjoy. Encourage your PBS station to continue airing art shows, as they are a great public service.

My sharing with you does not stop here. I am working to bring you more books with new compositions and techniques. My goal is to help you and others learn to paint with acrylics in a quick, easy and fun way.

I thank you for watching my painting shows, and for studying with me. It is a great honor. I wish you the best. Have fun painting!

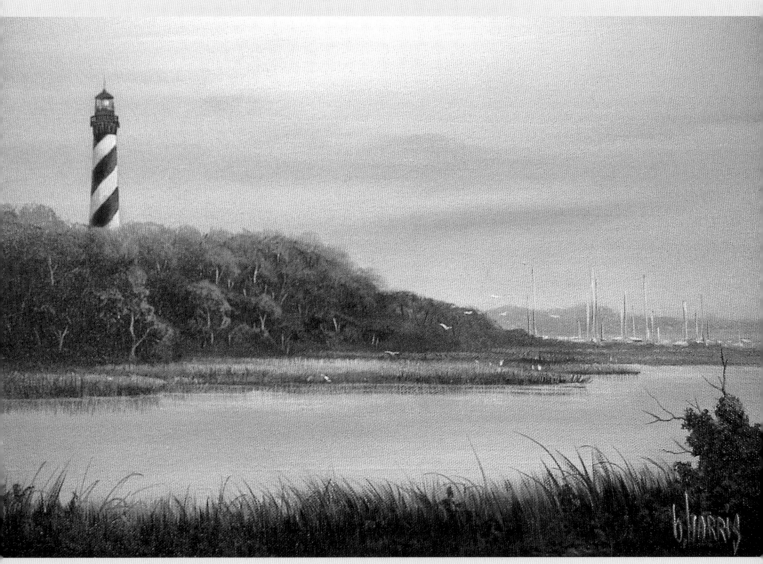

Approaching St. Augustine
16" x 20" (41cm x 51cm)

Patterns

Come On In
Enlarge this pattern 200 percent

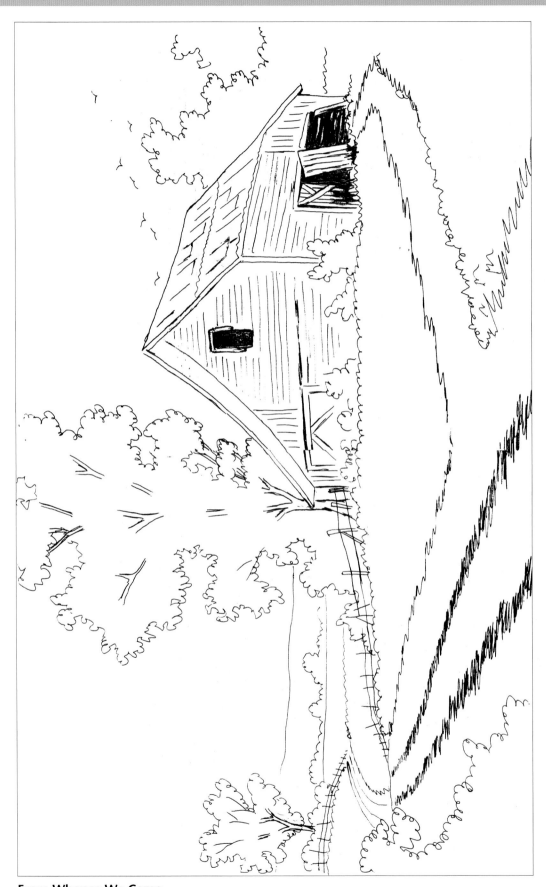

From Whence We Came
Enlarge this pattern 189 percent

By the Dock of the Bay
Enlarge this pattern 161 percent

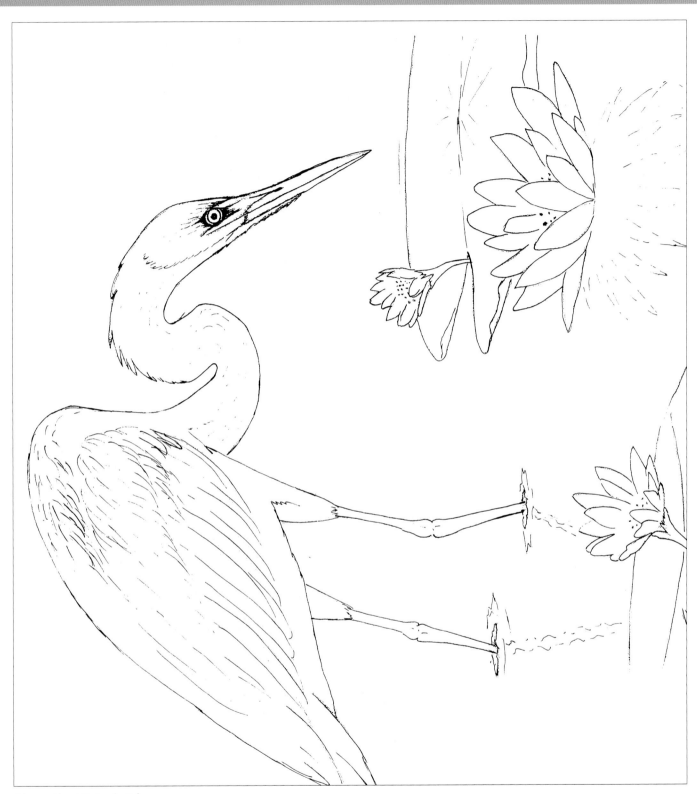

Along the Water's Edge
Enlarge this pattern 200 percent

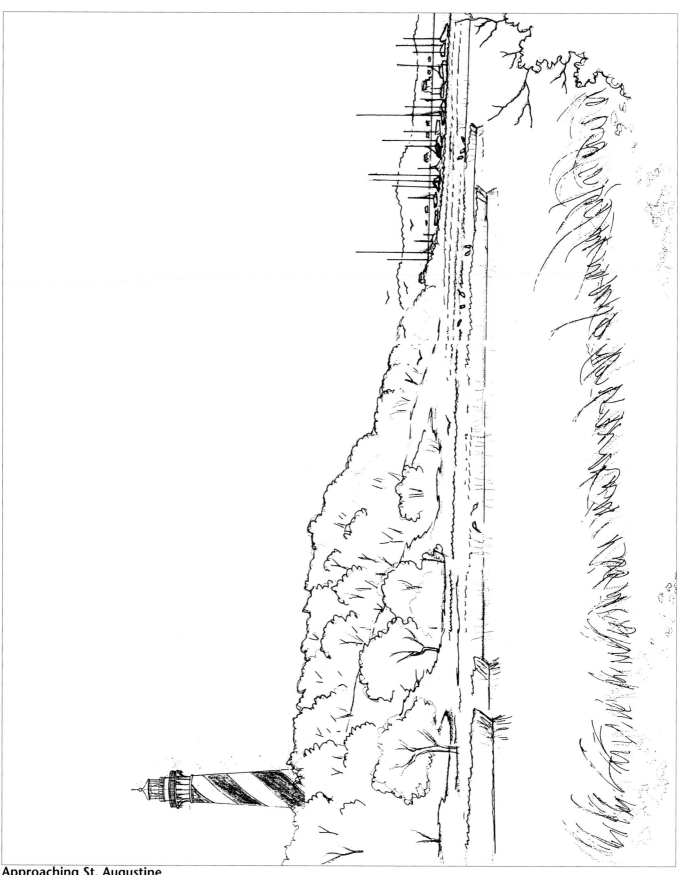

Approaching St. Augustine
Enlarge this pattern 154 percent

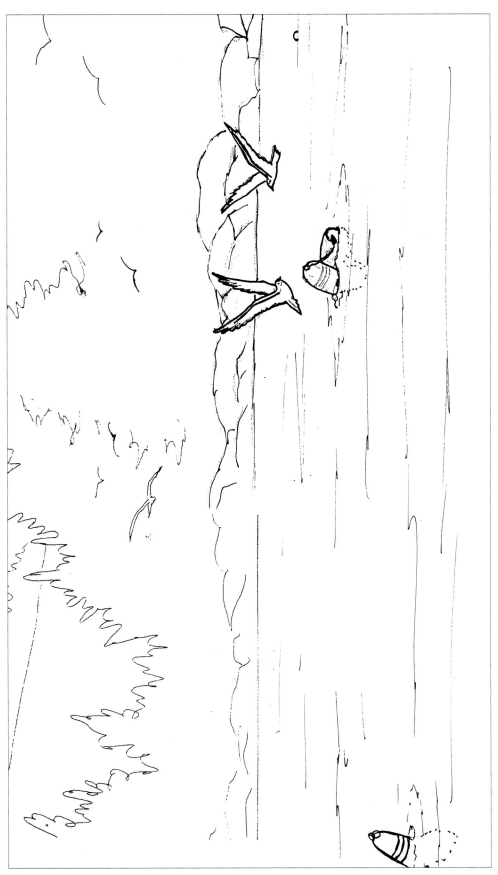

Maine Moorings
Enlarge this pattern 156 percent

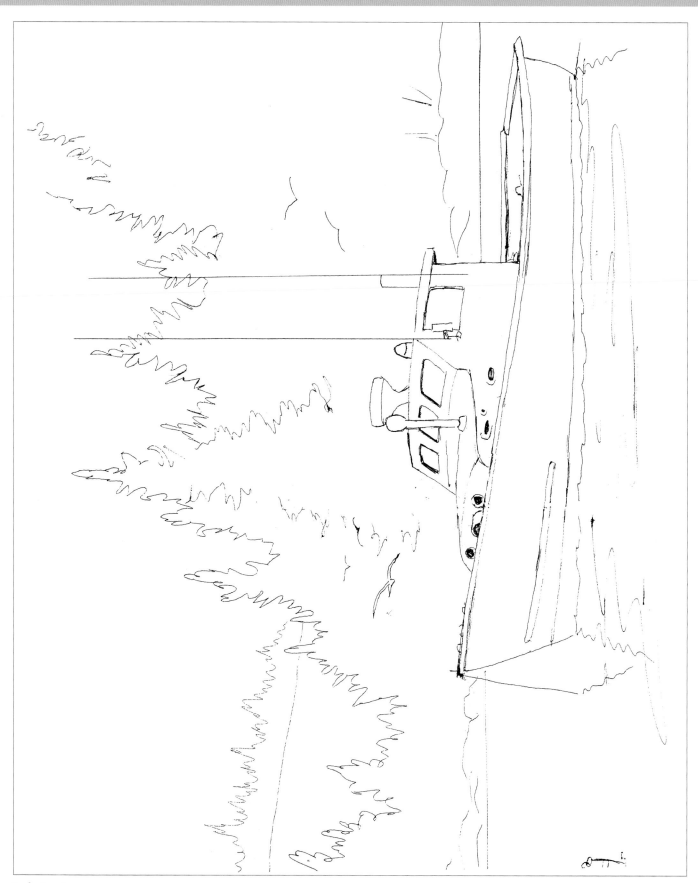

Lobster Joe
Enlarge this pattern 182 percent

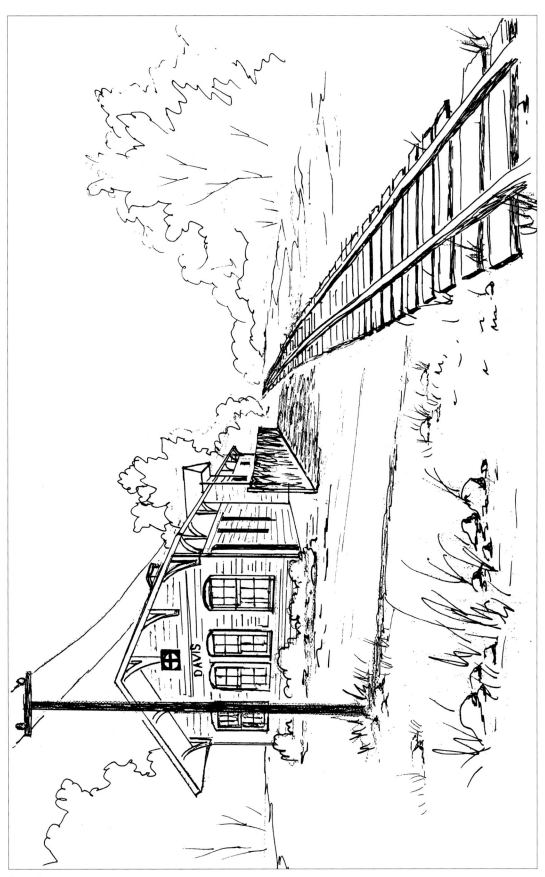

Last Stop
Enlarge this pattern 145 percent

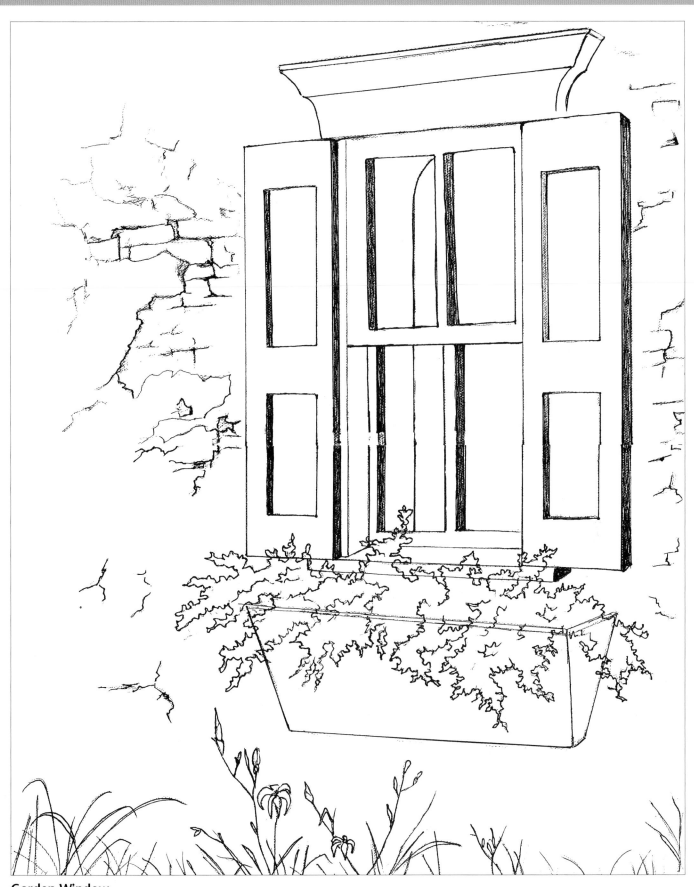

Garden Window

Enlarge this pattern 185 percent

Sky High
Enlarge this pattern 154 percent

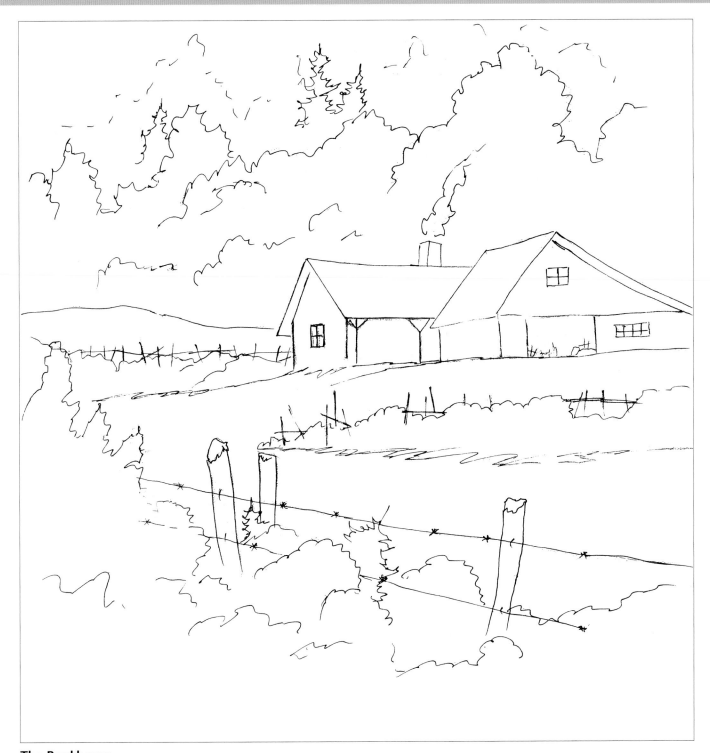

The Bunkhouse
Enlarge this pattern 185 percent

Tickled Pink
Enlarge this pattern 112 percent

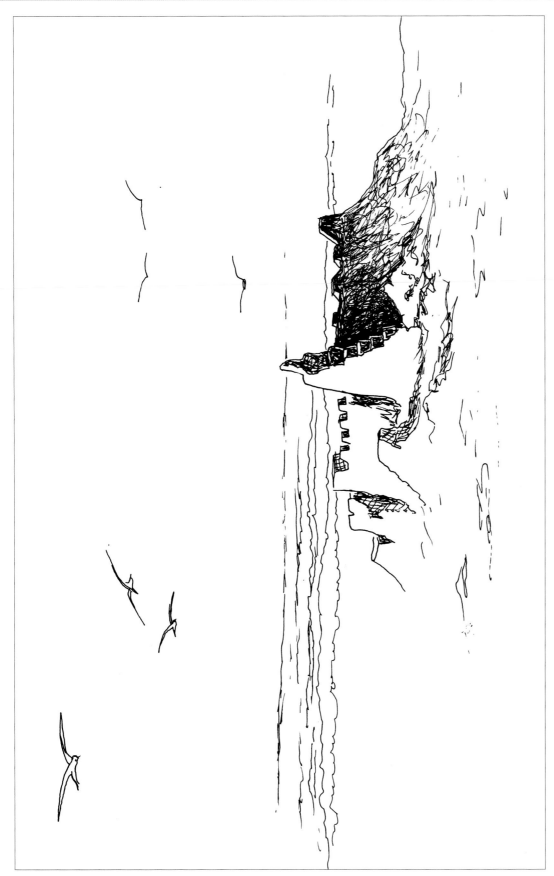

End of Summer
Enlarge this pattern 143 percent

Index

A

Acrylic modeling paste, 62-63

B

Backgrounds, 7
 laying in, 33, 85-86
Barns, 18, 23, 76, 78-79
 roofs, 23, 78-79
Birds, 25, 75, 94
 beaks, 33, 48
 eyes, 33, 48, 94
 feathers, 32, 34-35, 48
 highlights on, 34
 legs, 35, 48
Birds, types of
 egrets, 43
 Great Heron, 32-35
 seagulls, 43, 48-49, 55
Blending, 19
Boats, 30, 41-42, 50-55
Borders, 7
Bricks, 63-64
Brushes, 10-11
 loading, 10
 types of, 11
Buildings. *See* Barns; Bunkhouse;
 Train station
Buoys, 47-49, 54

C

Clearblend, 7-8
Clouds, 18-19, 68, 70-71, 77
 highlights on, 71
 layering, 71, 76
Color mixtures, formulas for, 13, 19,
 27, 32, 39, 45, 51, 57, 63, 69,
 77, 85, 91
Colors
 marbleized, 9, 14
 mixing, 8-9
 recommended, 9
Crunching, 10

D

Dandelions, 24
Depth, creating, 18, 26, 40, 60, 68,
 76
Design protector, using a, 7
Dock, boat, 26, 28-31
Drybrush, 31

E

Edges, soft, 8, 19

F

Feathers, 32, 34-35, 48
Fences, 13, 15-17, 22, 69, 75-76, 82-
 83
Ferns, 67
Flower box, 62, 66
Flowers, 17, 66-67, 84-89
 wild-, stippled, 43
 See also specific flower
Foliage, 12-17, 20-22, 24-25, 40-41,
 66-67
 distant, 58, 78
 foreground, 43, 81-82
 highlights, 15, 21-22, 41, 82
 middle-ground, 58, 80
 stippled, 13-14
French matting, 7, 26

G

Glass, 52-53, 62, 64
Grass, 24, 61, 73-74
 foreground, 42-43
 middle-ground, 40

H

Hills, 46
 distant, 20, 39

K

Knife, painting, 10, 80-81

L

Leaves, 16, 86-88
Light, reflected
 knifed, 80
 painted, 29, 71
 sponged, 15
 stippled, 21-22
Light, sun-, dappled, 15
Lighthouse, 41-42
Lily pads, 35-37

M

Masking fluid
 applying, 85
 removing, 87
Masterson Super Pro Sta-Wet palette
 system, 9
Mat template, 7
Matting, French, 7, 26
Meadows
 distant, 20, 78
 foreground, 81
 layering, 76
 middle-ground, 20, 80
Mediums, 8
 combining, 69-72, 74, 92
Mistakes, correcting, 11

O

Ocean. *See* Tide lines; Water, ocean;
 Whitecaps

P

Paints, 8-9
 drying of, 8
 layering, 8
 mixed, storing, 9
 mixing, with water, 8, 84
 See also Color; Mediums
Palette, using a, 8-9
 watercolor, 85
Paper, watercolor, 85

Paths, 14-15
 foreground, 24
Patterns
 reproducible, 97-109
 transferring, 7

R
Railroad tracks, 60
Roads
 distant, 20
 foreground, 24
Rocks, 28-29
 shoreline, 47
Runs, creating, 86-87

S
Sand, and paint, mixing, 90-91, 94-95
Sand castle, 92, 94-95
Sand dune, 72-73
Sandbars, 40
Scumbling, 47, 57-58, 70, 78
Shadows, cast, 60, 65-66
Shrubs, 61
Skies, 12-13, 19, 38-39, 45, 57, 68-69, 77, 91
 See also Clouds
Slowblend, 8, 11
Snow, 76, 79, 82
Sponge, using a, 15, 17, 67
Stippling, 10, 21-22
 sponge, 67
Stroke, comma, 93
Subject matter. *See* specific subject
Sunlight, dappled, 15
Supplies, basic, 8-11
 See also specific supply

T
Techniques, 7, 10-11
 borders, creating, 7, 26-28
 brush loading, 10

crunching, 10
design protector, using a, 7
drybrush, 31
knife loading, 10
matting, French, 7, 26
mistake correction, 11
pattern transfer, 7, 28
scumbling, 47, 57-58, 70, 78
stippling, 10, 67
tapping and patting, 11, 13
wet-into-wet, 8, 11, 14, 35, 46, 68
wet-next-to-sticky, 11
wet-next-to-wet, 11, 91
wet-on-dry, 11, 68
wet-on-sticky, 11
Texture, adding, 63, 90-91, 94-95
Tide lines, 72, 93
Touching up, 25
Train station, 56-57, 59-60
Transfer paper, 7
Trees, 41
 bark, 22
 distant, 13-14, 20-21, 46, 58
 fir, 78
 foreground, 21-22, 46-47, 58
 highlights on, 15, 22, 46, 58
 layering, 76
 leaves, 16
 limbs, 16, 22
 middle-ground, 20-21
 trunks, 16, 22, 59

V
Value, gradating, 9, 78

W
Water, 31, 39, 47, 55, 68, 72
 lines, 37, 41, 49, 92
 lines, rippled, 31
 ocean, 72, 91-93

reflections 26, 28, 35, 37, 40-41, 49, 54
Water lilies, 36-37
Watercolor, simulating, 84
 See also Paper, watercolor
Wet-into-wet, painting, 8, 11
Wet-next-to-sticky, painting, 11
Wet-next-to-wet, painting, 11, 91
Wet-on-dry, painting, 11, 68
Wet-on-sticky, painting, 11
Whiteblend, 8
Whitecaps, 72, 92-93
Wildlife, 32
Window shutters, 63, 66
Windows, 60, 62-66
Wood, 28, 63, 79

Learn to paint like the pros with these other fine North Light Books!

Beloved TV painter Brenda Harris brings all the charm and approachability of her PBS show directly to you with this easy to follow instructional guide. Thirteen step-by-step projects will have you painting heartwarming scenes ranging from landscapes and barns to flowers and birds. With templates that help you easily transfer every project to your canvas, *Painting with Brenda Harris* will have you creating fast and fun acrylic scenes in no time!

ISBN 1-58180-659-0, paperback, 112 pages, #33254

Create stunning masterpieces of your favorite creatures, be they cats, dogs, horses, sheep or even ducks! Jeanne Filler Scott provides template line drawings for every animal so painters of any level can start immediately. Follow 21 step-by-step demonstrations, and the clear instruction will lead you to beautiful acrylic paintings of all your favorite animals.

ISBN 1-58180-598-5, paperback, 128 pages, #33111

Everyone has photographs of their favorite pets, and now you can use them to create lifelike paintings of your furry and feathered friends! With bestselling author Lee Hammond's instruction, you'll learn how to break down an animal's features, paint complementary backgrounds and more.

ISBN 1-58180-640-X, paperback, 128 pages, #33226

Whether you're a decorative painter, professional artist or simply an animal lover, you won't be able to resist the cute, cuddly animals in this user-friendly guide. It's easy to paint lovable bunnies, kittens, puppies and more in both watercolor and acrylics with this comprehensive guide.

ISBN 1-58180-738-4, paperback, 128 pages, #33415

Creating great paintings doesn't require extensive knowledge of art theory—just your favorite photo, a few basic materials and this book! Discover how to turn your photos into beautiful paintings with these 40 step-by-step demonstrations, helpful how-to sections and wide variety of subject matter.

ISBN 1-58180-717-1, paperback, 208 pages, #33389

In both acrylic and oil, Dorothy Dent reveals the techniques behind the magic of light-filled landscapes, in a variety of weather conditions reminiscent of Thomas Kinkade. Enjoy the clear instruction from this true master of painting light and the expert teaching on all four seasons.

ISBN 1-58180-736-8, paperback, 144 pages, #33412

These books and other fine North Light titles are available at your local fine art retailer, bookstore or online supplier.